the little book of
Logo Recipes

David E. Carter

HDi

**HARPER
DESIGN
international**

An imprint of HarperCollins*Publishers*

THE LITTLE BOOK OF LOGO RECIPES
Copyright © 2004 by David E. Carter and HDI,
an imprint of HarperCollins*Publishers*.

First published in 2004 by:
Harper Design International,
An imprint of HarperCollins*Publishers*
10 East 53rd Street
New York, NY 10022

Distributed throughout the world by:
HarperCollins International
10 East 53rd Street
New York, NY 10022
Fax: (212) 207-7654

HarperCollins books may be purchased for
educational, business, or sales promotional use.
For information, please write: Special Markets
Department, HarperCollins Publishers Inc.,
10 East 53rd Street, New York, NY 10022.

Library of Congress Control Number: 2003114961

ISBN: 0060570245

Printed in Hong Kong by Everbest Printing
Company through Four Colour Imports,
Louisville, Kentucky.
First Printing, 2004

This is the first of a new "Little Books" series. The Big Books that I have edited over the past years have found a very large audience and more will be coming soon. (*The Big Book of Design Ideas* became a top seller, even cracking the amazon.com "Top 1000" list. Quite an accomplishment for a book not written by John Grisham, and not a diet book, but one for a very specialized market.)

The Big Books are edited for the graphics professional, and they show outstanding work from all over the world. If there is a single weakness to the Big Books, it's that there is no "reason why it's good" or "how this was done" text given for the work shown.

There is a large number of young designers (and aspiring designers) out there who want (and need) a book that includes that kind of information. The Little Books series is directed to that market. While many professionals will probably buy the Little Books, they have been priced so that those on tighter budgets (including young designers and students) can afford them.

And the content has been analyzed enough to let those without heavy experience get a better understanding of the "why" and "how" of the work included.

This Logo Recipe Book is the first of the series. For some, it may be a little elementary. But for those who need a "jump start" on the logo design process, and for those who ask "how was that done?" this is the book for you.

The next book will be *The Little Book of Layouts.* It will have hundreds of great layouts, and each will have a "why it's good" explanation.

For all of you who asked for this new series of books, we hope you like what we're doing.

table of

Contents

Circle Shapes

Here's how to make it…

The circle is the most common shape for logos. The reasons are many: the circle is a pleasing shape, it fits well for most logo applications, and it is very versatile when used with the name set in type. This section will begin with common circle logo "recipes."

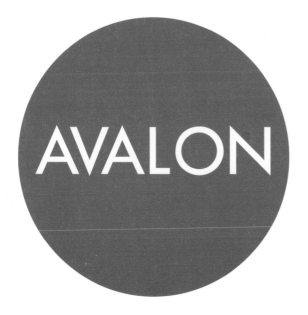

Here's how to make it…

*Step 1: Circle
Step 2: Place type in center of circle.*

Note that this is a basic font, and the logo is simple, yet effective.

The previous logo was very simple. Now, we add some additional visual interest by moving the type from its "dead center" position into an unbalanced look.

Step 1: Circle
Step 2: Type in place, off center.

Avalon, the name is below the circle design, and the letter A is the dominant visual feature in the circle. Now, we're going from simple to a more complex design.

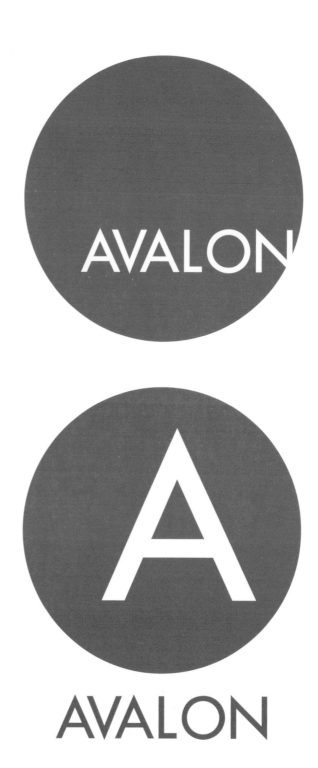

Here's
how to
make
it...

Now, let's go for
the unbalanced
position for the A
inside the circle.
Note how the dotted line
shows the visual align-
ment between the A in
the name below the de-
sign.

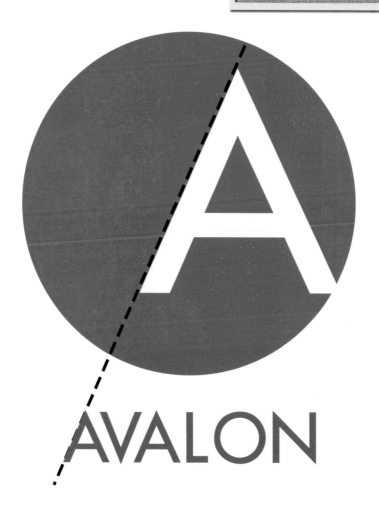

Here's how to make it...

*Here we have an interesting visual device created by making the letter A extend beyond the edge of the circle.
Try this with different letters as you create logos.*

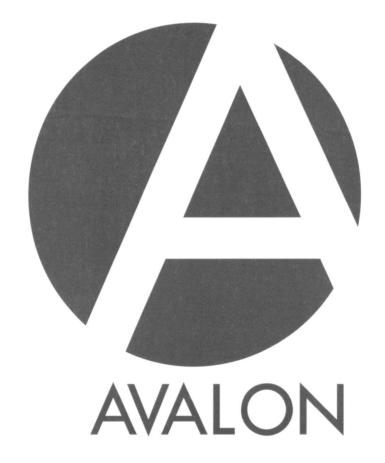

AVALON

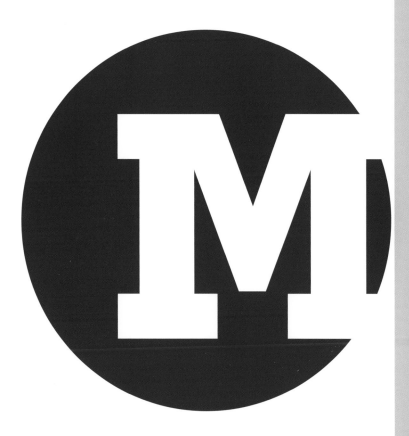

Let's look at the circle
and ask a couple of
questions.
What goes in the
circle?
Where does the
company name go?

Note how using the
Letter M in a block
font gives it visual
interest when it is
placed at the right
edge.

The alignment of the logo (M inside the blue circle) and company name is fairly basic, even though the effect is interesting.

But we'll use this for a stepping stone to go on to other visual variations.

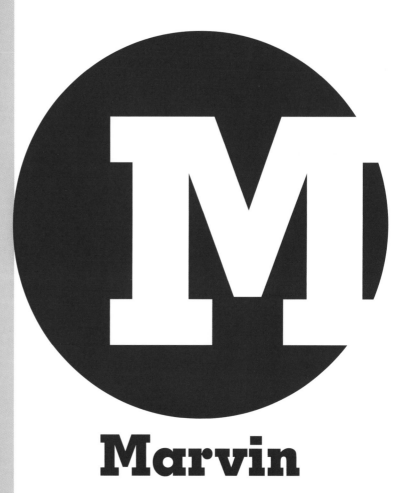

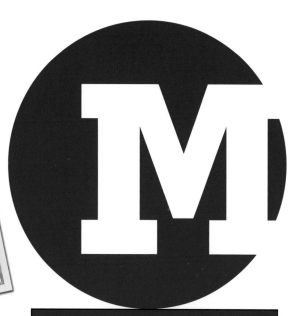

Here's how to make it…

By simply adding a horizontal box below the M and the blue circle, we have created some visual contrast. Changing the color of the box to red gives even more contrast to the logo.

Red is a more power-
ful color than blue.
Since the circle is
larger than the rect-
angle, we have
changed the larger
element to red, to
maximize the impact
of the brighter color.

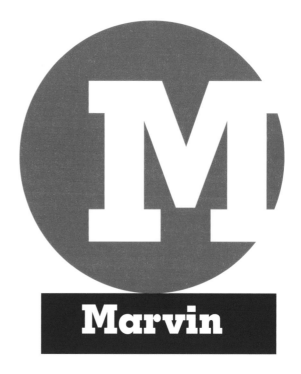

Now, let's go back to
the issue of "what
goes in the circle?"

Instead of just adding
the block M, we have
added a set of graphic
lines to give emphasis
and movement to the
M.

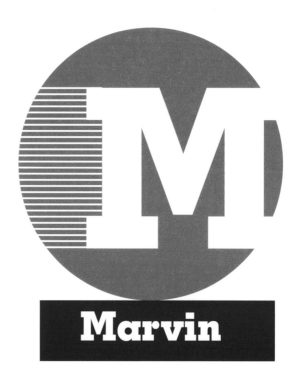

Here's how to make it...	Circle Shapes

You are not confined to using letters in the circle. Anything goes. There are more examples in other sections of this book, including "design elements, animal shapes," etc. The key to good logo design is "open your mind, because anything is possible."

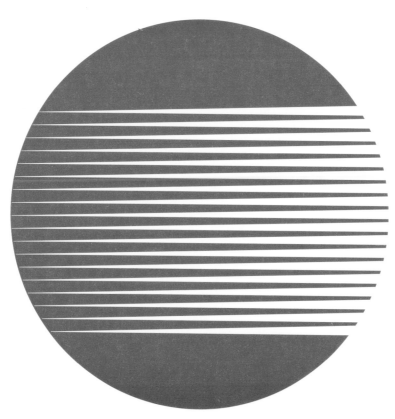

Marvin

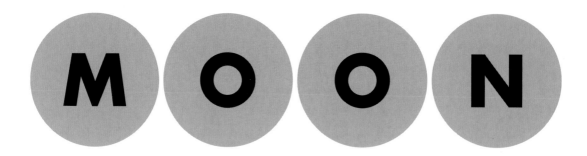

MOON

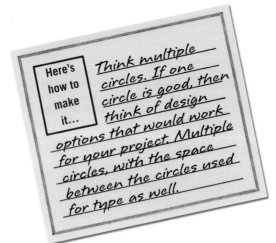

Here's how to make it... *Think multiple circles. If one circle is good, then think of design options that would work for your project. Multiple circles, with the space between the circles used for type as well.*

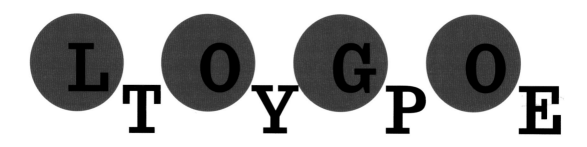

LTOYGPOE

Now, consider how using a white circle on top of a colored circle can create interesting graphic effects.

Step 1: Start with the red circle.
Step 2: Copy the circle, change it to white,(here, the white circle is shown with a black edge, to show positioning.)
Step 3: The dotted line has been removed creating a crescent shape.
Step 4: Set type in place.

Red Moon Cafe

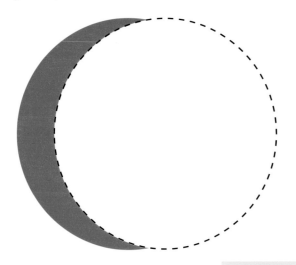

Here's how to make it...

Circle Shapes

Using a basic circle, then cov-
ering part of it with a white
circle can give interesting
results. Here's the basic starting point
again.
By simply copying the two circles and
then aligning multiple copies across the
page, the effect below appears.

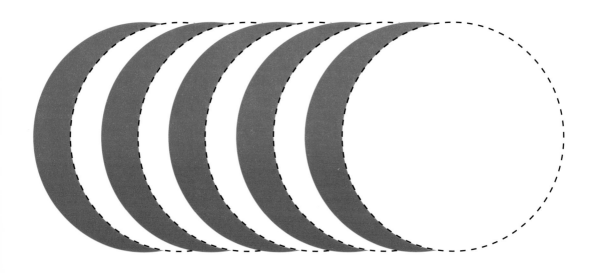

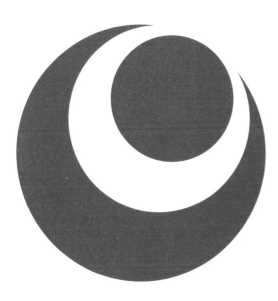

Circle Shapes

Here's how to make it...

The interesting graphic above is simply 3 circles of different sizes.

Start with a circle, then think other shapes.

The graphic shown at the lower right is simply a white triangle put over a red circle.

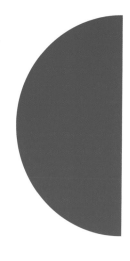

Here's how to make it... Circles cut in half can make interesting shapes for logo design.

If your initials are DC (mine are), this can make a nice start for logo design.

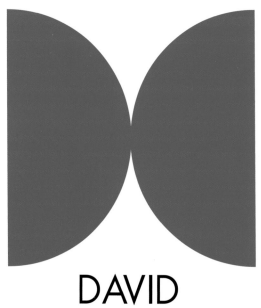

DAVID CARTER

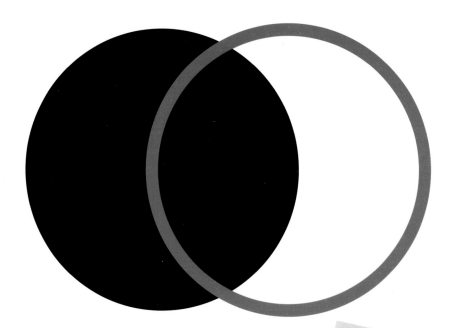

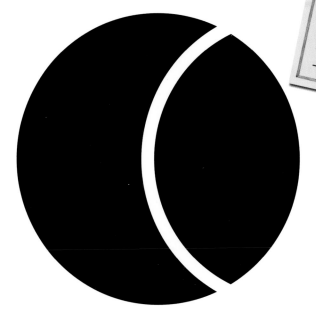

Here's how to make it...

A black circle.
And a red circle,
with no fill.

Step 1: Change the red
circle to white.
Now, let's turn the page
and continue with this
thought.

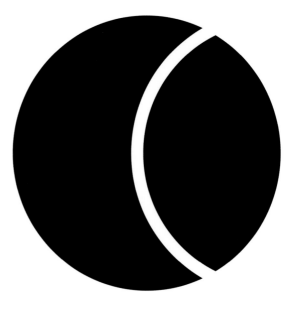

Here's
how to
make
it…

Continue with
this element and
now…
Add another
white circle, in reverse
position. Change the
black to light green. Add
type.

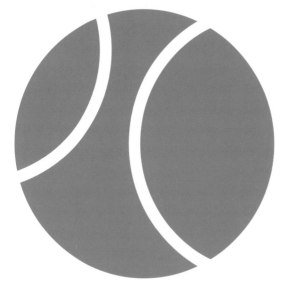

**Southern Hills
Tennis Club**

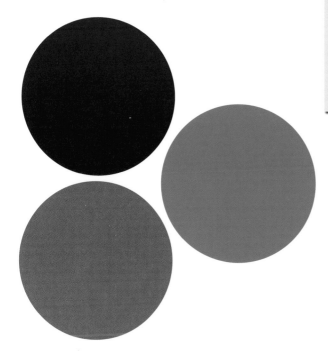

Here's
how to
make
it...

Multiple circles, with multiple colors, make a good beginning for good logo designs... As we shall see on the following pages.

Add a background
circle, and you get a
whole different look.

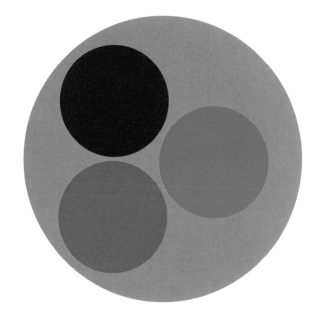

Multiple circles
combined with two
colors can create a
nice logo. Here, the
color variation creates
the initial L.

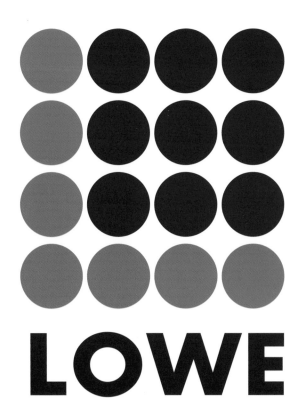

SPACE

Here's
how to
make
it...

_Multiple circles,
by changing the
sizes progressively
we end up with
a nice "space" look.
Here, multiple circles are
used as a design element
below a strong type face._

STRONG

When you think
"circle" also think
"oval."

Like this.

Using the basic
design above, the
finished logo to the
right was created by
taking the original
logo into PhotoShop,
and using the "Bevel
Boss" and "Gradient
Glow" feature of Eye
Candy 4000. (See the
section later in this
book on PhotoShop
and Eye Candy Fil-
ters.)

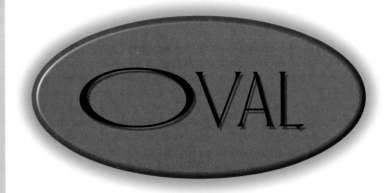

| Here's how to make it... | *Overlapping various colors of ovals can create very interesting effects. Let's start with just one to show the process. Adding multiple ovals in various colors, creates a nice graphic.* |

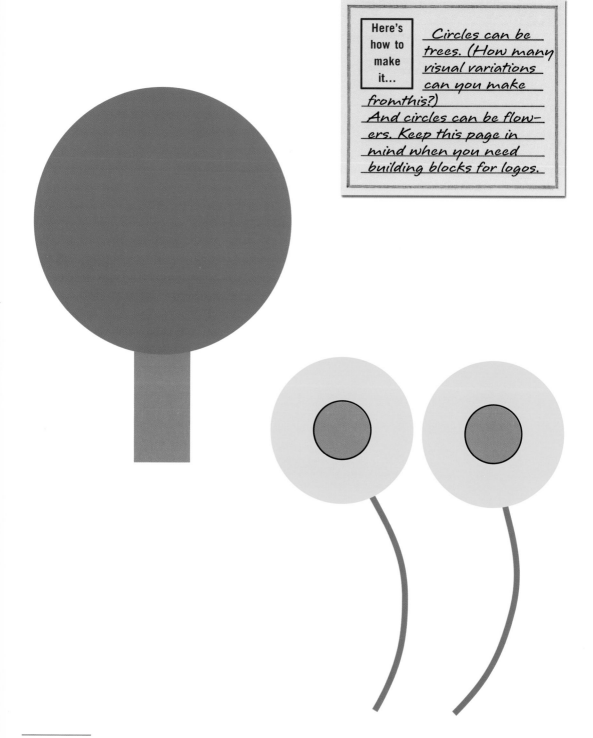

Here's
how to
make
it...

Circles can be trees. (How many visual variations can you make from this?)
And circles can be flowers. Keep this page in mind when you need building blocks for logos.

Here's how to make it...

Circles make good devices with a typographic logo. Look for letterforms where a round shape can substitute. How many can you think of?

WIN NOW

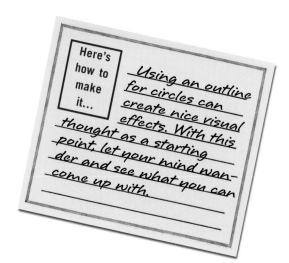

Here's how to make it...

Using an outline for circles can create nice visual effects. With this thought as a starting point, let your mind wander and see what you can come up with.

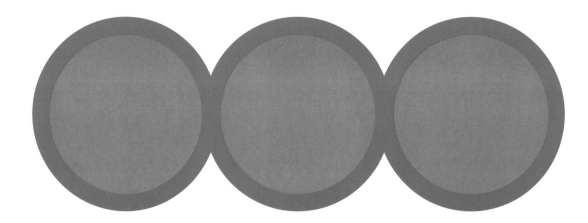

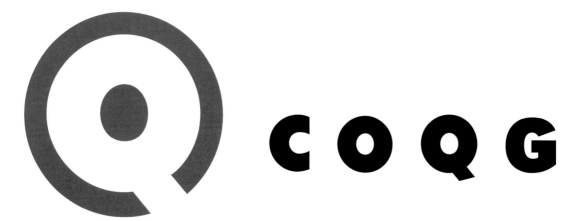

C O Q G

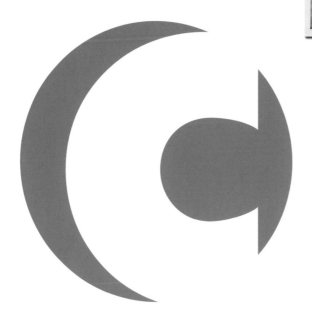

Here's how to make it...	Combine a circle background with a letterform that is also cir-

cular. C, G, O, and Q are obvious choices. Experiment with various fonts, as well as the placement of the letter on the circle.

Circle Shapes

Here's how to make it...

Other letters might be less obvious, but with a little imagination, they can work quite well with the circle shape— As in the examples below.

D J P R

D P

J R

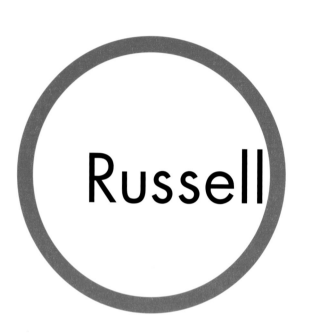

Here's
how to
make
it...

Circles without a fill color can also work for logos. Simply setting the name along with a circle has some interesting possibilities. Experiment with placement of the letter.

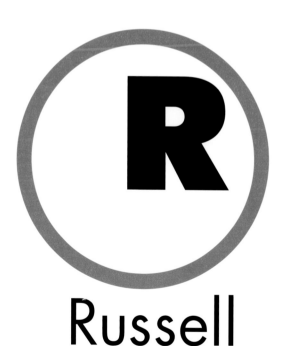

Multiple circles with no fill can be used to create interesting graphics. Here is just one example of how this can work. Experiment on your own with different line thicknesses, different placement, and different colors.

Here is just one possible permutation of the multiple circles with no fill.

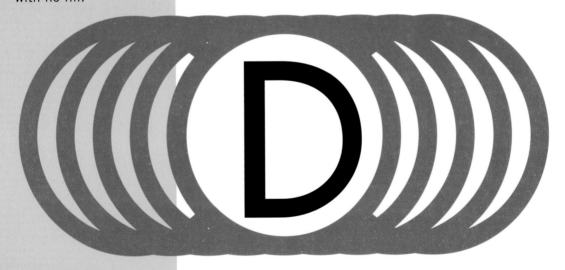

Here's how to make it...

For an interesting variation, try a circle with multiple colors inside it. As you can see on this page and the next, the variations are endless.

DAWN

DUSK

Ocean
Sunrise

Here's how to make it...	*Another example of using a circle within a circle. Experiment with placement, size and color. This is a nice effect.*

Circle variations are
nearly endless. Here
is a simple but effec-
tive use of two differ-
ent takes on circles.

ORBIT

Using an oval as an
"orbit" track, and
using a circle as a
body in orbit.
Simple concept.
Nice design.
Let your mind open
up to possibilities like
this.

Here's how to make it...	*Using white elements to "subtract" from the basic circle shape can result in some interesting effects such as these graphics.*

This globe graphic
was created (except
for the equator and
poles) with circular
elements.

George
Stevens
Resources

The circle is an excellent shape for enclosing a bold graphic such as this paw print.

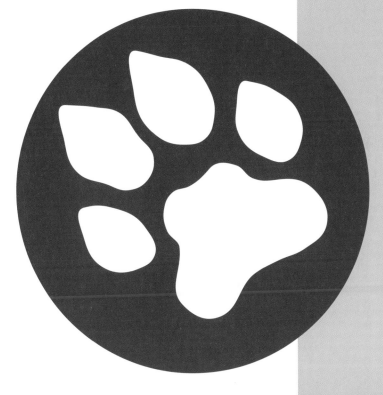

ASHLAND TOMCATS

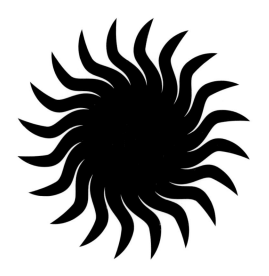

Here's how to make it...	When you are thinking in terms of circles, let your mind expand to circular shapes, with extensions such as this sun image.

Sunshine State

Here's how to make it...

Here is another variation of a circular shape with extensions. This shape is very easy to make in any drawing program, and can be quite interesting when imagination is added.

Holiday Productions

BRIGHT

Here's how to make it...	When designing a logo, try to think outside of the box. On the previous page, the shape below was used as a logo. Here are two examples of using it as a secondary device on a logo.

FIREWORKS

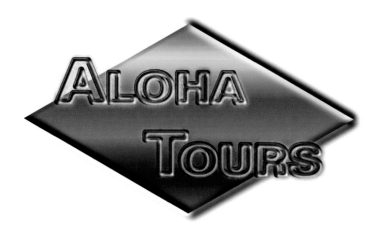

TypeStyler Effects is program full of special type effects which any designer will find useful. Relatively simple to learn, it offers nearly limitless type treatments. See what we came up with on the following pages.

Here's how to make it...	TypeStyler Effects

Aloha Tours: Select "Diamond Shape." Use "Rainbow Pillow Emboss" to get color background. Add type on top.

Arizona: Select "Vertical Arc." Use "Desert Horizon Block" effect to get colors.

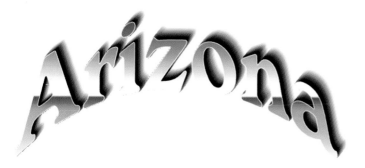

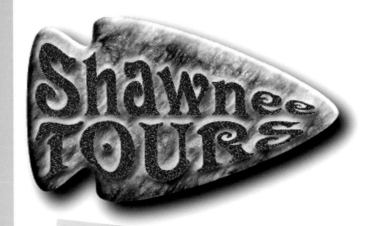

TypeStyler Effects

Shawnee Tours: Create the arrow background in "Style Workshop" using "Gray Slate." Can be made from 2 shapes or 1. When using 2 shapes, select "Tile Image." Place top line of type over arrowhead. Use "Top Arch" type style, and shape to fit. For bottom line, use "Bottom Arch" and shape to fit.

The Bob n Dave Show: Start with a rectangle. Apply "Rainbow Pillow Emboss" from "Style Library." Choose type, using different colors and sizes to taste.

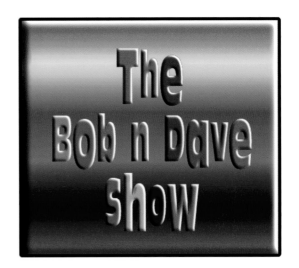

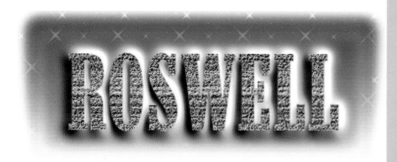

Roswell: Select "Rectangle." Use "Degraded Edges" to get color background. Add "Sandstone" type to finish.

TypeStyler Effects

Here's how to make it...

Bucko's: Select rectangle shape to start. Select "Bevel Edge" and choose color. Main line "Bucko's" is standard straight type, while "fifties restaurant" uses "Double Arch" type feature with modifications to obtain elongated shape.

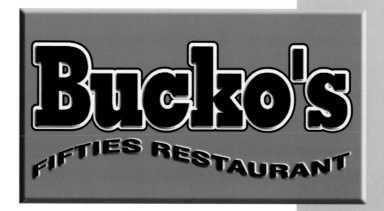

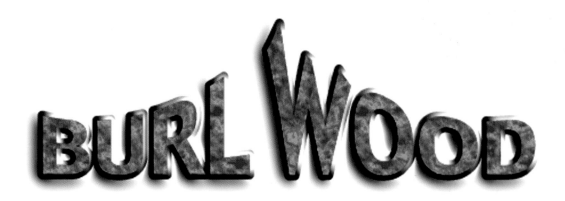

Here's
how to
make
it...

*Burl Wood:
From Shape
Library, choose
"Double Bezier." Use
"Burl" effect.*

Font is Charcoal.

Here's
how to
make
it...

*Candy Cains:
Create black
rectangle. Set
type. In "Style
Workshop", set back-
ground at white, outline
"Fill" at vertical; "Inline" is
pink, "Outline" is horizon-
tal rainbow.*

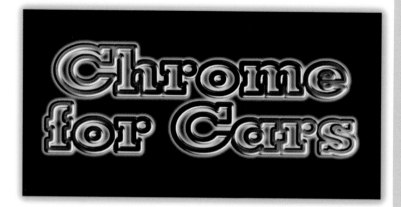

Chrome for Cars:
Begin with a rect-
angle and apply
"Black with Glow"
from the Style Library.
Font is Charcoal,
using "Silver" from
the Effect Library.

Here's how to make it...	TypeStyler Effects
	Cimarron: Select rectangle shape, which will become the background. Select "Surf Sunrise" from Image Library in Style Workshop. Place type over background and select "Wood with Sunrise Glow" from Image Library in Style Workshop.

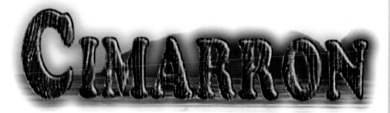

Here's how to make it...	TypeStyler Effects
	Clowns: Select a rectangle. Use "Desert Horizon Block" effect. Put type on top, using "Sandstone" type effect.
	D: Select square shape. Apply "Brass" effect. Placing type on top, apply "Brass" effect again.

Here's how to make it…

TypeStyler Effects

Fish-Fry: Choose "Fish" shape. Choose type effect with multi colors.

Eclipse: Select "Rectangle" shape. Apply "Eclipse with Rainbow Glow" effect. Put type on top.

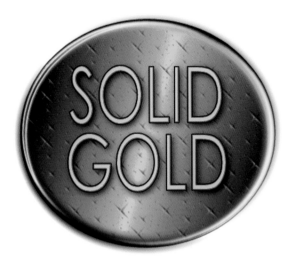

Here's how to make it...	TypeStyler Effects

Solid Gold: Draw circle stretch to create oval, change color to gold. Type: Gold inline with shadows.

Haines/Field: We use two base circles with multiple points, one red the other black. The top circle and strip are added and stylized with TypeStyler fonts and shapes.

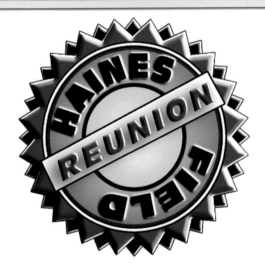

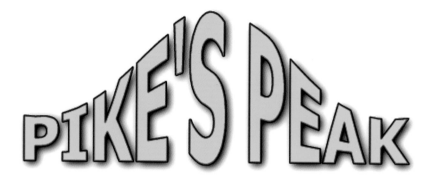

Here's how to make it...

TypeStyler Effects

Pike's Peak: Select Double Beziers. Choose font to create desired image.

Castle Rock: Vertical Art for both type blocks. Use "Desert Horizon" for effect on both.

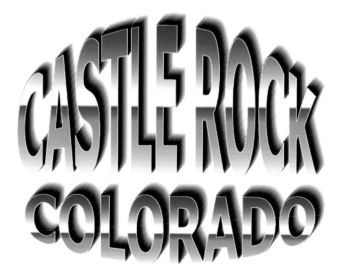

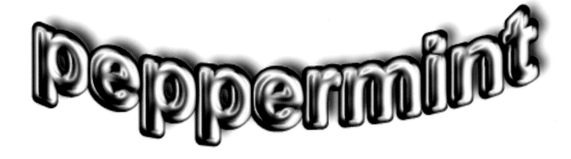

Here's how to make it...	TypeStyler Effects
	Peppermint: Select "Vertical Arch Bottom." For type, apply "Red Gloss."
	Psycho Deli: Select "Square" shape. Apply "Psychedelic" effect. Put type on top, choosing font and colors to match.

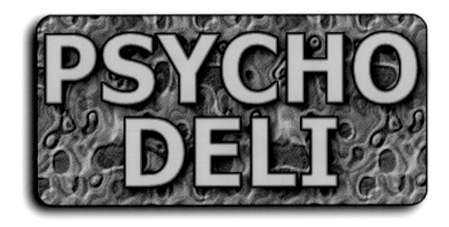

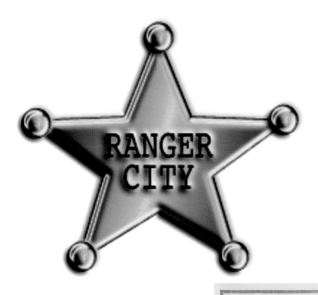

Here's
how to
make
it...

TypeStyler Effects

_Ranger City: Select "Star"
shape. Add circles to end of
points. Apply "Brass" effect.
Put "Type on Top."_

_Darwin: Select "Six Sides" shape. Use
"Wine Emboss" effect and stretch to
proper width. Place type on top._

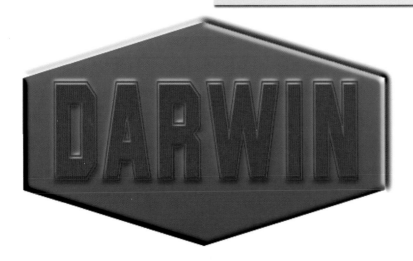

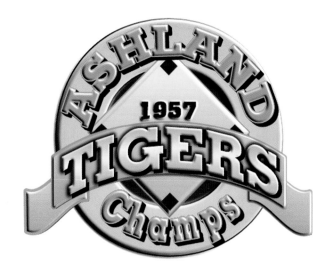

TypeStyler Effects

Here's how to make it...	

Tigers: Create various back‑ground shapes: Circle, diamond, one vertical arch (for Tigers), and 2 double arches (at either end of tigers). Use "Brass" effect on these shapes. Apply type with appropriate type style for each type block.
Winners: Select "Pennant" shape. Use select type style

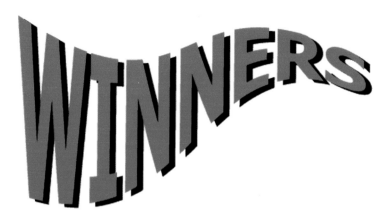

The Shadow Knows

Here's how to make it...	TypeStyler Effects

We started with "Helvetica Med-
ium Condensed" font, then
used "Wine Emboss" on the
font, and inserted the long shadow in
"Style WorkShop."
WhoDunnit?: A reverse shadow was
added in "Style WorkShop."

WHoDunnit?

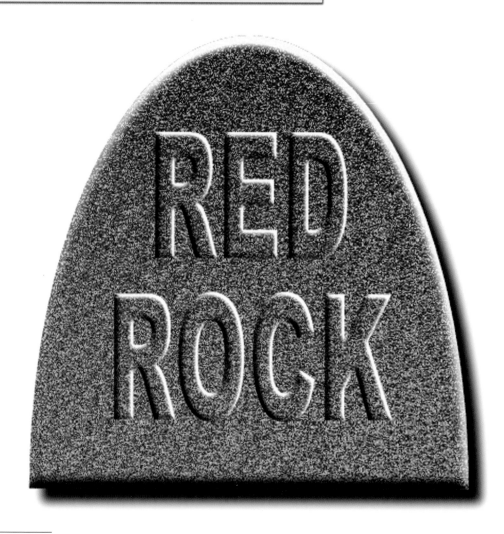

| Here's how to make it... | TypeStyler Effects |

Red Rock: The half circle shape was the start of this logo. The Red Granite texture was applied in the "Panel Attributes" window. The matching Red Granite emboss font was done similarly in the "Text Attributes" window.

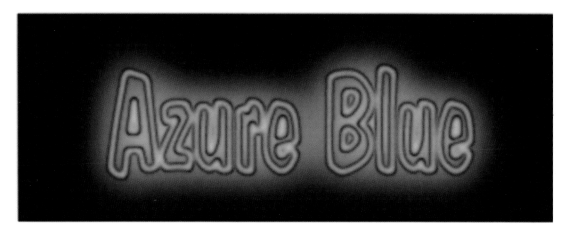

	TypeStyler Effects
Here's how to make it…	*Azure Blue: Simply use the "Neon" effect in TypeStyler.*
	Tomcats: Use the "Superstar" font to get the athletic shirt look. Then use "Vertical Arc" to achieve the top shape.

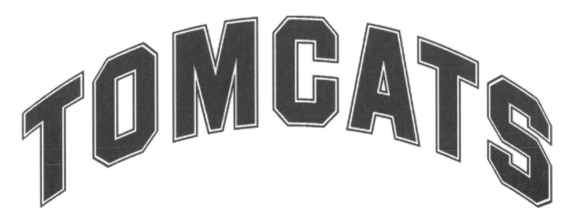

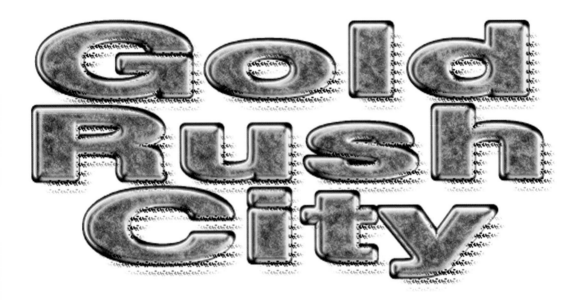

Here's how to make it...

TypeStyler Effects

This logo was created in Type-Styler, the letters are standard. "Gold" in the "Text Attributes" window. The background is a pattern created in the "Style WorkShop" feature of TypeStyler.

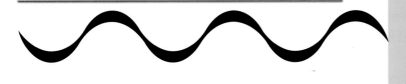

This simple waveform can be used in many ways and take on numerous shapes.

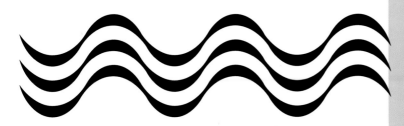

The same waveform has 3 lines and not one. A few pages over you'll see just how versatile something like this can be.

David E. Carter created a set of more than 2,000 such design elements in a product called Logo SuperPower. The set is available for Mac or PC on a CD-ROM. For information, call (606) 329-0077.

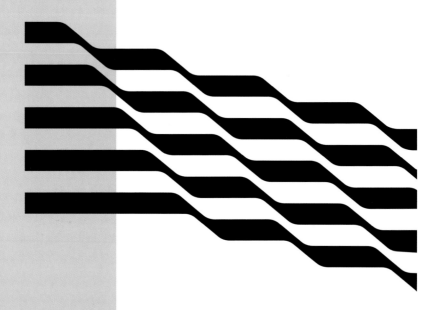

This basic shape
(shown above) has a
lot of potential uses in
logos. Keep turning
the pages and see.
You probably see the
"flag look"
already in the design
element below.

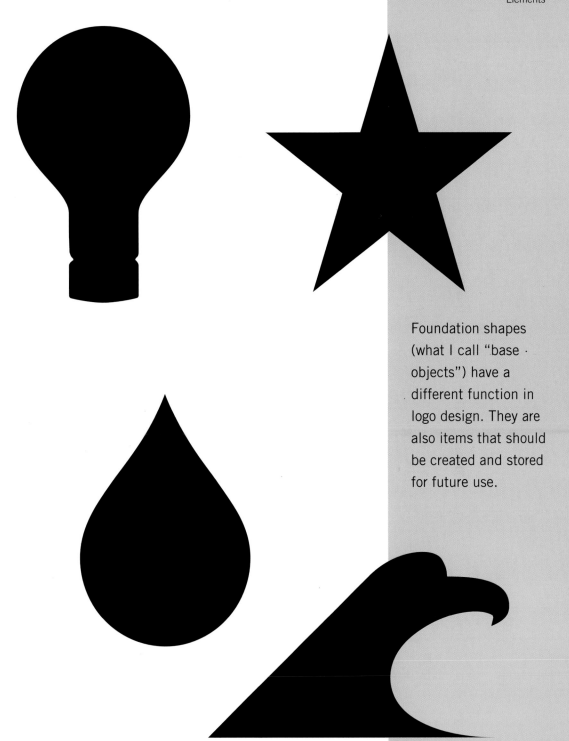

Foundation shapes
(what I call "base ·
objects") have a
. different function in
logo design. They are
also items that should
be created and stored
for future use.

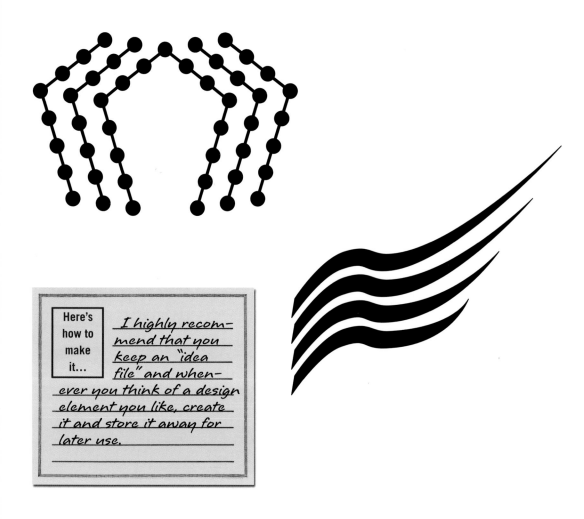

Here's how to make it...	*I highly recommend that you keep an "idea file" and whenever you think of a design element you like, create it and store it away for later use.*

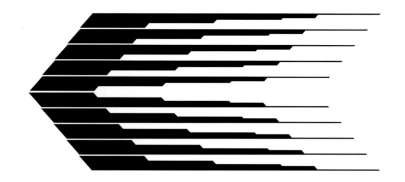

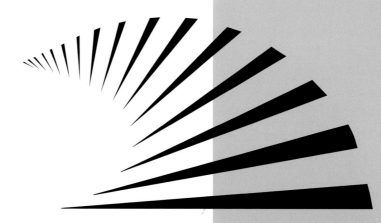

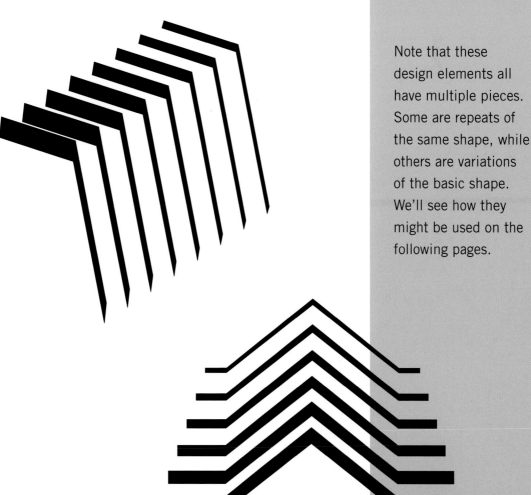

Note that these
design elements all
have multiple pieces.
Some are repeats of
the same shape, while
others are variations
of the basic shape.
We'll see how they
might be used on the
following pages.

Here's how to make it...

Design Elements

Just to see some of the possibilities of using design elements, let's start with the concept of combining the waveform with a water drop.

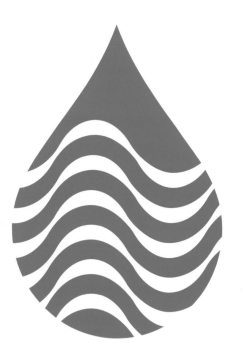

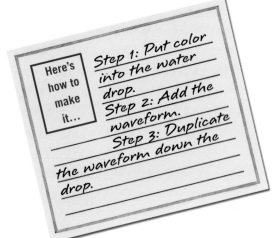

Here's how to make it...

Step 1: Put color into the water drop.
Step 2: Add the waveform.
Step 3: Duplicate the waveform down the drop.

<table>
<tr><td>

Here's how to make it...

</td><td>

Design Elements

One of the interesting things about using design elements is that the shapes can be dis-torted (compressed and extended) in a drawing program such as FreeHand (where these were created) and you get a whole different look. To demon-strate this, we'll use the 3 stack version of the waveform, and the same drop.

</td></tr>
</table>

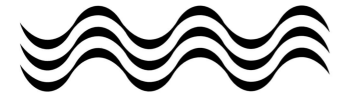

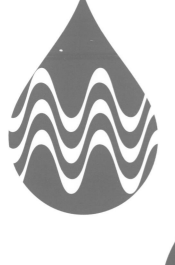

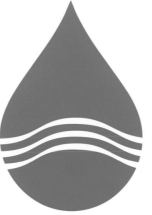

For each logo, these were the steps:
Step 1 - Change color of drop.
Step 2 - Change waveform to white.
Step 3 - Extend (or compress) waveform.
Step 4 - (for some designs) Duplicate waveform on drop.

> **Here's how to make it...**
>
> ## Design Elements
>
> *Here we will combine two design elements and create a compelling logo in the process.*
>
> *Step 1: Start with the flag stripes element.*
> *Step 2: Bring in the eagle head graphic.*

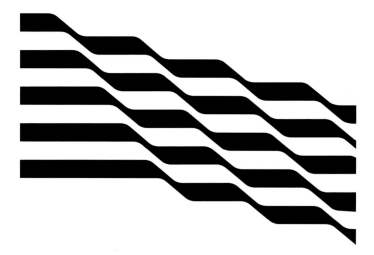

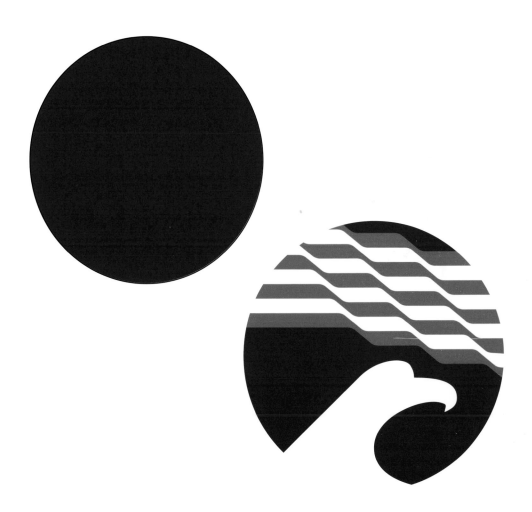

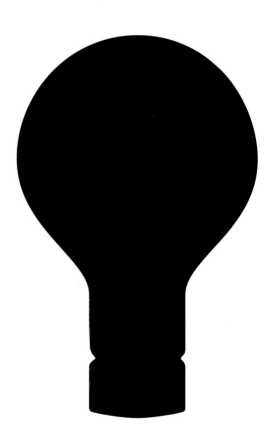

Sometimes, the simplest design elements can result in very striking logos. For example, the graphic above is the starting point. Next, we use the light bulb as our base object.

Here's how to make it…

Design Elements

Step 1: Change light bulb to blue.

Step 2: Bring in design element, change it to white.

Step 3: Copy white element down the light bulb, and position to fit the curve of the light bulb.

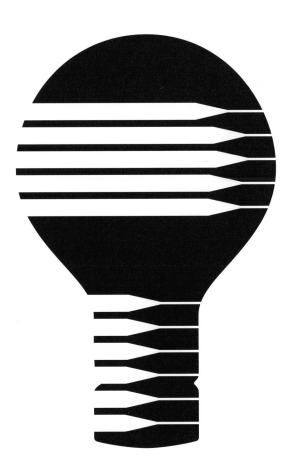

Simple design elements can be made into more complex elements by grouping multiple copies of the element together. The simple element to the right shows the versatility and power of having design elements as part of your design capabilities.

Here, the element at the top of the page has been used as a graphic device with a rectangular box, a striking visual effect.

Beginning with the simple graphic effect at the top of the page, we then created a more complex graphic effect, shown here to the right, one made up of multiple copies of the original design.

Galasso

Design Elements

We will now start with the complex graphic and see how it might be applied to the logo design process…

Step 1: The effect is simply placed on an oval and changed to white.

Step 2: The letters M and W are brought in, and the stroke is modified to make it fit into the primary graphic.

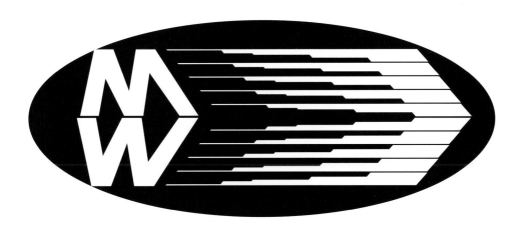

OK. This is a nice start. But the design doesn't really "pop" off the page. How can we make it better? Let's go to the next page, and think Photoshop.

Here's how to make it...	Design Elements
	Step 1: We started by opening the file from the previos page in PhotoShop.
	Step 2: We used the Eye Candy 4000 "Bevel Boss" tool to create a dimensional look that is now a very contemporary design that really works.

Here's how to make it...

One last step for added dimension: We took the previous logo back into PhotoShop and used the "Shadow Lab" feature in Eye Candy 4000. The resulting drop shadow gives added depth and impact to the logo design.

Let's stay with the complex design element, and the single design element for a little longer.

Now, let's assume that we're in the thinking stage of creating a logo for a company whose name begins with a letter "T".

OK, you go to your "Design Elements" file and you see the complex Graphic at the top of the page. You just might see how that design could be worked into a nice logo. Watch and see how.......

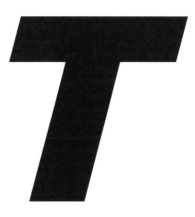

Here's how to make it...

Design Elements

Step 1: Skew the T to make it into an italic letter.

Step 2: Change the color of the T.

Step 3: Bring in the single element. (Here, the complex element was an idea generator, it won't be used, at least not in its present form.)

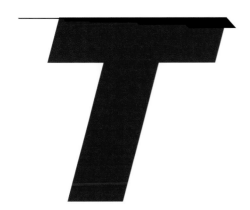

Here's how to make it...

Step 4: Place the single design on top of the letter T.

Step 5: Stretch the element so that it is wider than the letter.

Step 6: Change the angle at the right end to match the angle of the letter T.

Here's how to make it...

Step 7: Copy and paste the graphic down the top portion of the letter T. (Clue as to what's happening: The purple T will eventually go away. It's being used now only as a guideline on where to place the elements).

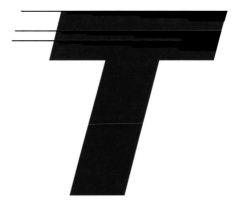

Here's how to make it...	Design Elements
	Step 8: Copy the series of elements at the top of the T, and do the same thing on the rest of the letter.

OK, it doesn't look right.
Now it's time to modify the graphic so
that it works.

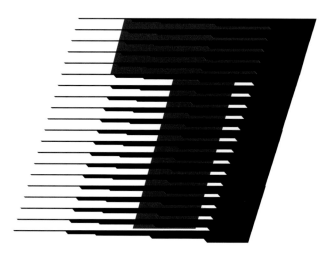

Making this change is a start.

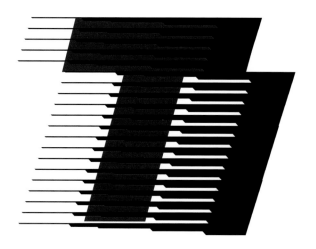

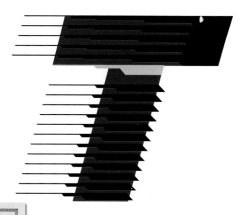

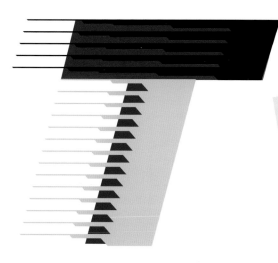

Here's how to make it...

Design Elements

We placed the elements down the stem of the T, then worked to modify the basic element so that it would "work" with the existing elements at the top of the T. That element is shown here in yellow to show details.

Here's how to make it...

Step 10: The modified element is now copied all the way down the base of the T. (Still shown in yellow for clarity.)

Here's
how to
make
it...

Working with the design element, and simply using the trial and error method, a pleasing graphic emerges.

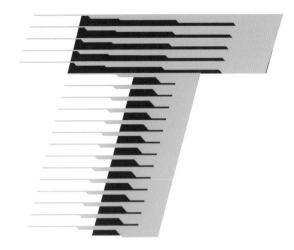

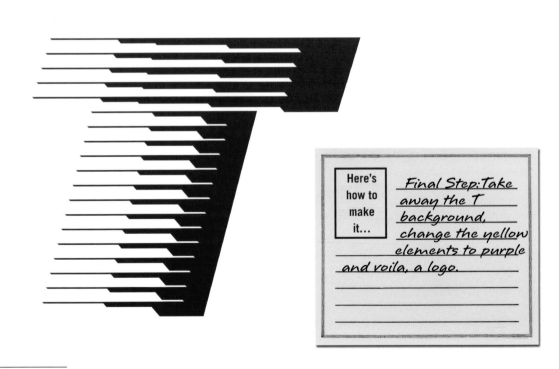

Here's
how to
make
it...

Final Step: Take away the T background, change the yellow elements to purple and voila, a logo.

Here's the kind of design element that you might come up with just as a concept. It's fairly easy to create, not especially time consuming, and you can store it. OK. Now is the time to use it. You have a client where the type design might be appropriate. Client's name is Low. You see some possibilities...

Here's how to make it...

Step 1: Get one part of the design element. Modify it to get a stylized L. Turn it to white.

Step 2: Draw a green circle.

Step 3: Duplicate the L graphic.

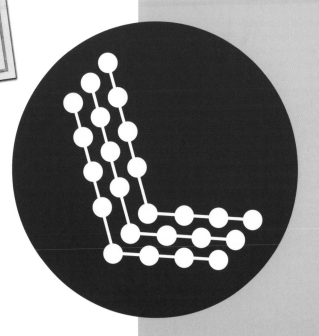

| Here's how to make it... | Next, we took the design into Photoshop and use the "Crystal-lize Filter", Now, it's getting interesting |

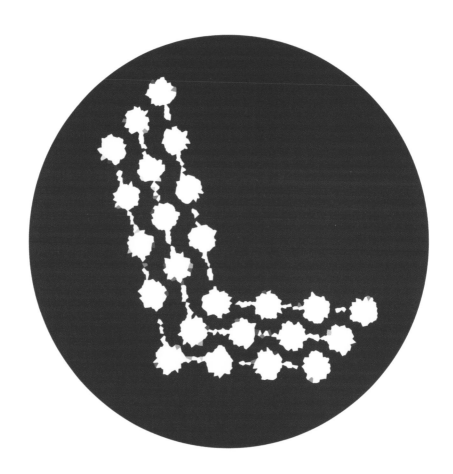

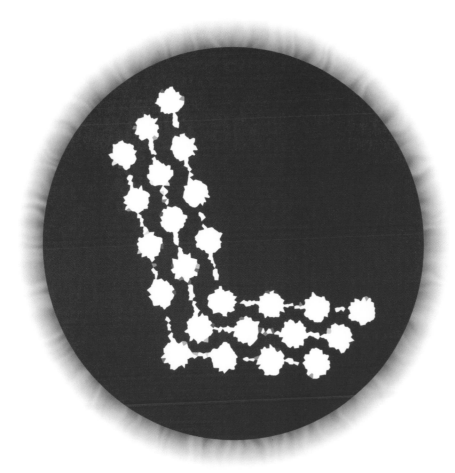

Here's
how to
make
it...

*To get the final
effect, we used the
Corona Filter.
Note that
PhotoShop filters have
many options as to color,
size of effects, etc.*

Here's another nice design element, simple, yet strong.

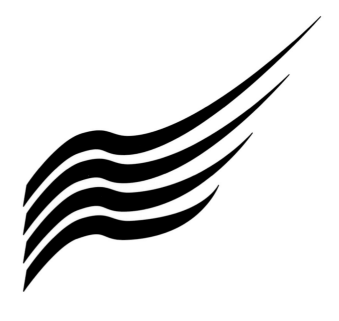

Step 1: Draw a rectangle with rounded corners.
Step 2: Add wing graphic, change to fit box.
Step 3: Add type at bottom.

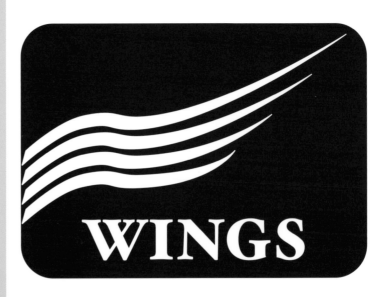

Here's how to make it...	*If you want to add special effects, PhotoShop is the place to do it.*

This logo was opened in PhotoShop and the "Glass" Filter" was used, selecting only the wings and type.

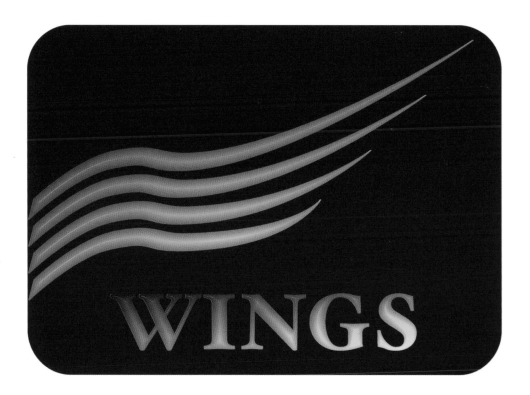

This design element is simple, but has some strong visual appeal. You can make this kind of design element quickly and easily using "Blend" tool in FreeHand.

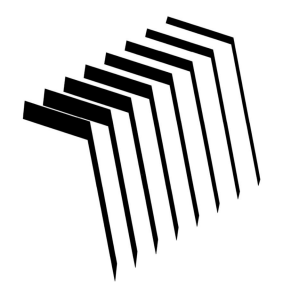

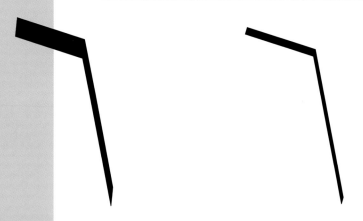

Here's how to make it...	Design Elements
	Step 1: Create the design shown to the bottom left.
	Step 2: Copy that design, move it to the far right; then modify the design. (Note the thickness of the strokes has been changed.)
	Step 3: Use the "Blend" feature in FreeHand, and specify 6 intermediate steps.

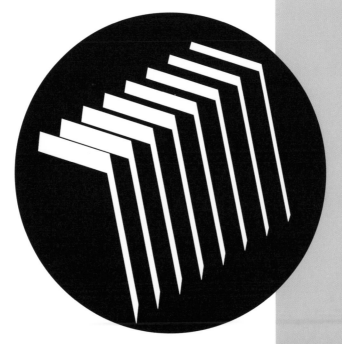

HydroElectric Inc.

Finally, we use the design element shown on the preceding page to create a logo. Circles are strong background elements, so that's what we have used here.

Now, we want to make this logo for a HydroElectric company into one that symbolizes electricity from water power, so:

Here's how to make it...

Step 1: Use "Gradient Glow" feature in Eye Candy 4000, a PhotoShop plug-in.

Step 2: Put the shadow behind the logo within Shadow Lab in Eye Candy 4000.

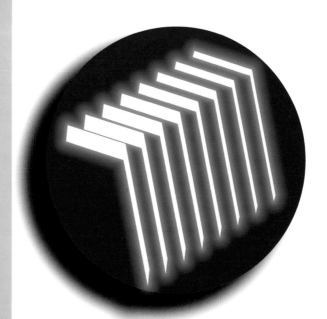

The result is a strong logo, modern and one that visually shows the business category.

HydroElectric Inc.

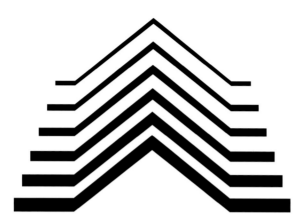

Here's another design element that is very strong, and one that's very simple to make.

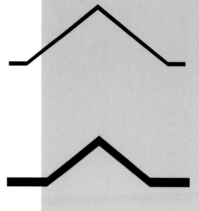

Here's how to make it...	Design Elements

Step 1: Draw the bottom element. Step 2: Do not draw this as a line element; create it as a long rectangular box with a peak in the center. Step 3: Use the "blend" tool in FreeHand, specify 4 intermediate steps, and you get the design element shown at the top of this page.

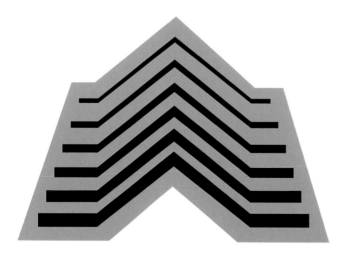

Let's use this basic shape to create the background for the design elements. This is a good start for a very memorable logo.

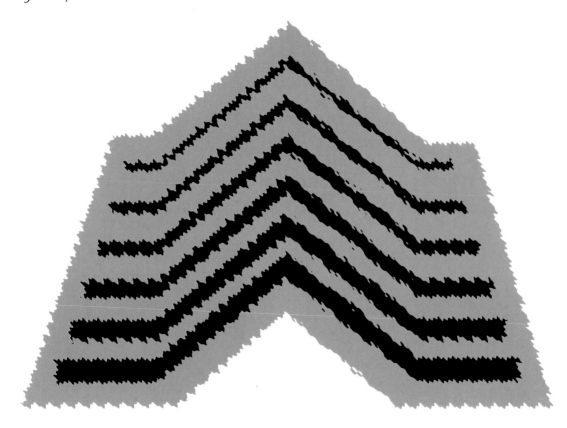

Here's how to make it...

To create this striking logo for Earthquake Measurement, the design was taken into PhotoShop and the "Ripple" filter was used.

This is a very interest-
ing design element.
The way it curves as
though disappearing
into a spiral gives it
an unusual visual
appeal.

Design Elements

Here's how to make it...

Step 1: Create the basic ele-
ment, (the one on the bottom,)
in FreeHand. Step 2: Clone
the original shape, and reduce the size
to 95% of the original. Step 3: Move the
new, smaller element upward. Step 4:
Under Edit, "Duplicate" this function 15
times to create the design element.

Once the design
element has been
created, we simply
place it in a circle.
NOTE: The circle is
an excellent shape for
logo designs. Besides
being visually pleas-
ing, it works well as a
background for many
design elements. This
design could well be
used "as is." But,
we'll take it into
PhotoShop and see
what we might do
with it.

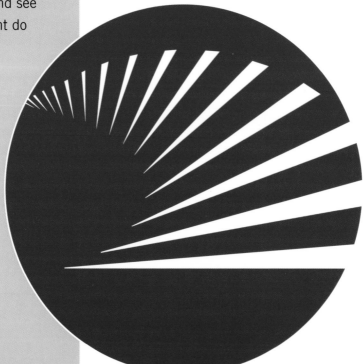

Here's how to make it... The logo was simply taken into PhotoShop, and the filter option "Crystallize" was used to achieve this stunning effect

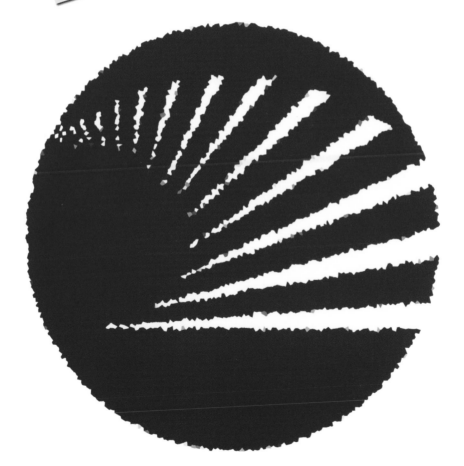

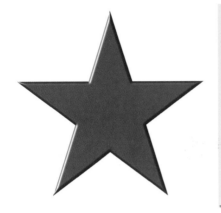

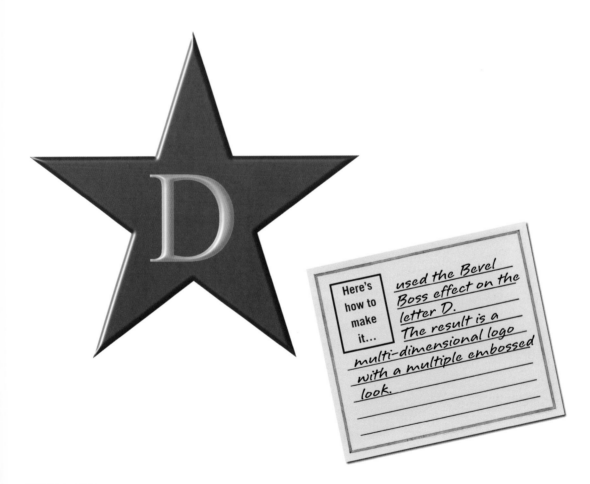

Here's how to make it...	Design Elements

The star shape has an infinite number of applications.

To get this effect, we took the blue star into PhotoShop and use the Bevel Boss tool in Eye Candy 4000 to get the bevel edge effect. Next, we put the letter D on top of the beveled star, then selected the D and once again.....

Here's how to make it...	used the Bevel Boss effect on the letter D. The result is a multi-dimensional logo with a multiple embossed look.

Here's how to make it...

Here is another example of how you can use a simple design element such as a star and come up with a striking design.

Here's how to make it...

For this graphic, we simply took the star into PhotoShop and applied the gradient Glow effect.

PhotoShop has many built-in filters that allow the user to create some very complex-looking effects quite easily. **Eye Candy 4000** is a "plug-in" set of filters for PhotoShop. This is a highly versatile software product that can help you achieve striking effects in seconds. Most all of the Eye Candy 4000 filters have multiple variable controls with the filter, to let you have maximum control over the final look of the effect.

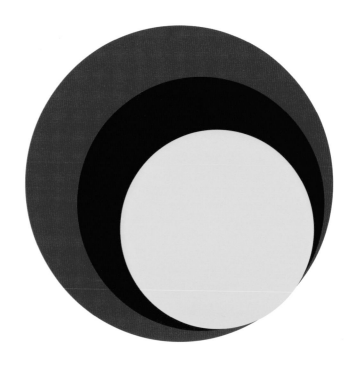

Here's how to make it...	PhotoShop/Eye Candy

To demonstrate, we start by creating this design by over-lapping circles stacked at the bottom right quadrant. This basic design will be used throughout this section to show how PhotoShop effects and Eye Candy 4000 effects can help strengthen your graphics.

<table>
<tr><td>Here's
how to
make
it...</td><td>

PhotoShop/Eye Candy

Open the basic design in PhotoShop, then under "Filters" choose Eye Candy 4000 and use Bevel Boss to create the button effect you see here. Note that Bevel Boss has many different possible profiles, giving you great control over the bevel shape and effect you create.

</td></tr>
</table>

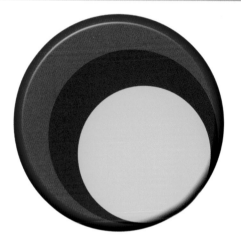

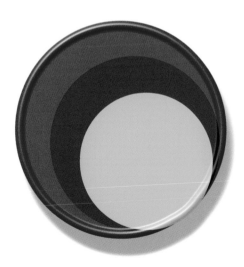

The effect shown to the lower left is also a creation of Bevel Boss. Instead of using a button effect, we used this ridged profile. Once the Bevel Boss portion was done, we used another Eye Candy effect, the Shadowlab to create the subtle drop shadow at the lower right in the graphic. Shadowlab also has many ways to control the size of the shadow, position, capicity and other factors.

> **Here's how to make it...**
>
> ## PhotoShop/Eye Candy
>
> _The 3-circle design was imported into PhotoShop and the "Distort-Ripple" effect was applied._
>
> _Remember that you have control over the size of ripples, frequency and other attributes. Imagine how you could use this for your own designs._

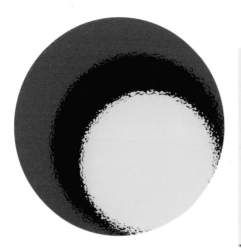

> **Here's how to make it...**
>
> _Using the PhotoShop Filter "Distort Ocean Ripple" gives this interesting effect to the design shown on the left._

Using the PhotoShop
Filter "sponge" gives
us this interesting
effect.

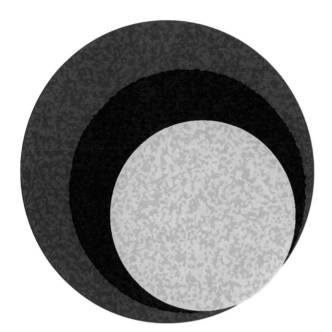

The effect shown here
is created using
Pixelate: Color Half-
tone effect in
PhotoShop.

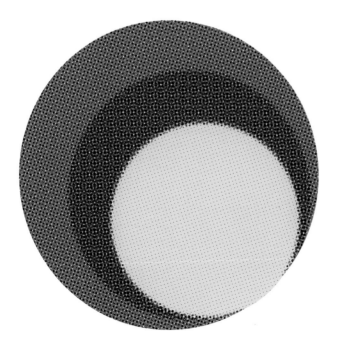

Here's how to make it...

Using the Photo-Shop Filter "Radial Blur" produces this interesting effect.

Here's how to make it...

Eye Candy 4000 has a "jiggle" filter that gives many interesting effects, such as this one.

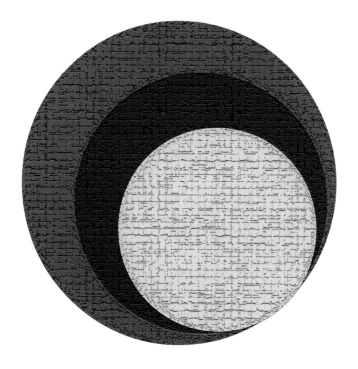

Numerous texture variations are available in the PhotoShop filters. This effect was done using Texture: Craquelure.

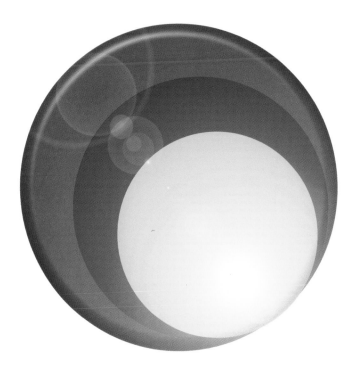

This graphic effect has two steps: Bevel Boss in Eye Candy, then Lens Flare.

Remember that most of the PhotoShop filters and Eye Candy 4000 filters have multiple controls, allowing many variations within the filter's output.

Additional filter
applications will be
shown, using this
simple design as the
foundation.

This effect was
accomplished by
using "Water Drops"
filter in Eye Candy.

Here's
how to
make
it...

This interesting effect is created by using the "Squint" filter in Eye Candy 4000. Keep this section handy for future reference on your next project.

The Distort Ripple,
Large filter in
PhotoShop made this
effect happen quickly.

The Zig Zag filter in
PhotoShop creates
interesting effects.

Photoshop's Distort: Pinch filter gives looks like this. Again, there are many visual options within the filter.

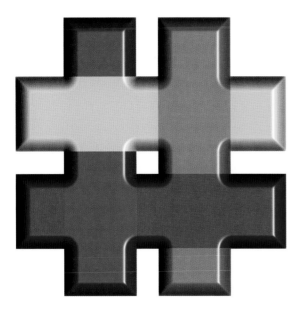

Eye Candy's Bevel Boss is a great tool, with many different bevel profiles and other controls that are very easy to use.

Eye Candy's Gradient Glow has a huge array of effects within that one filter. Slider Controls allow many different looks, and the colors are another area with unlimited options.

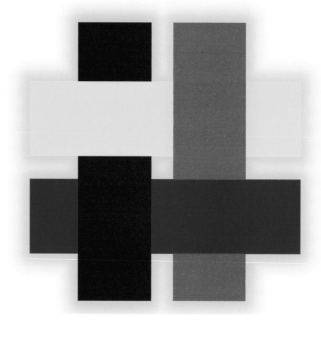

The Eye Candy 4000 "Drip" filter greatly enhances simple graphics.

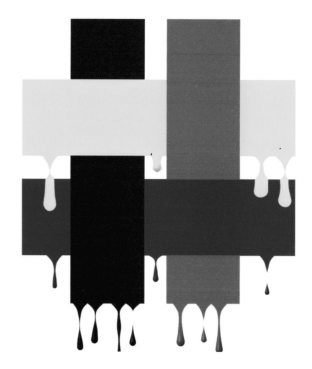

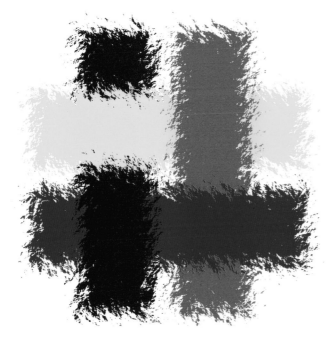

A jiggle is created with the aptly-named "Jiggle" filter in Eye Candy 4000.

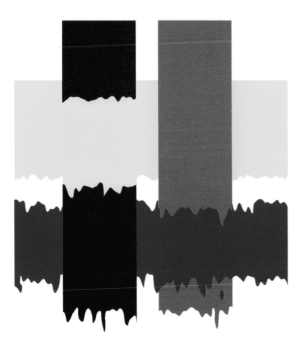

"I'm Melting!" Easy graphic to create with Eye Candy 4000's "Melt" filter.

The PhotoShop
Stylize: Wind Blast
filter gives interesting
effects like this
quickly.

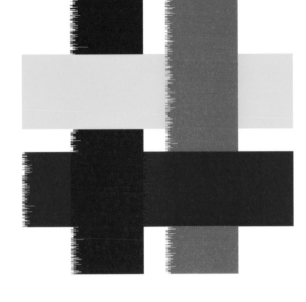

A woven look is
achieved with the
"Weave" filter
PhotoShop.

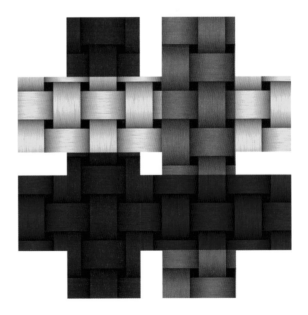

Simple letters, a
single initial, can be
made into exciting
logos by using
PhotoShop or Eye
Candy 4000 filters.

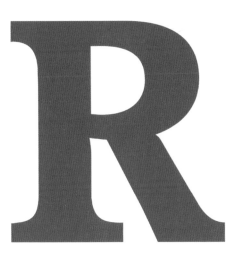

The "Chrome" filter in
Eye Candy 4000 turns
this simple letter
above into an exciting
metallic look shown at
left.

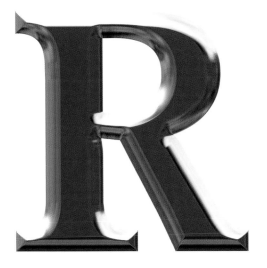

This design started
with the red R, then
two steps of filters
were used...
First, the "wood"
grain was applied in
Eye Candy 4000.
Then, the wood grain
texture was taken into
Bevel Boss to give the
finished effect.

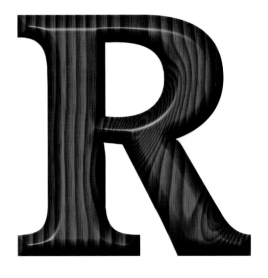

Finally, the above
design was taken into
the Shadowlab filter
of Eye Candy 4000 to
create the drop
shadow effect.

Note about Shadowlab:
This is a highly
versatile tool for
creating many varia-
tions of shadow
effects. You have
control over many
aspects of the shadow
so the look you desire
can be acheived
quickly.

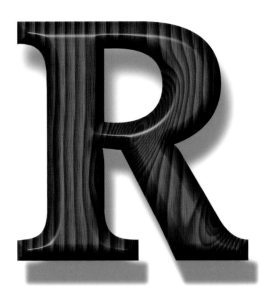

Here's how to make it...

The Lens Flare filter in Photo-Shop allows you to get this look, while giving you many different areas of control, such as brightness, angle of reflection, etc.

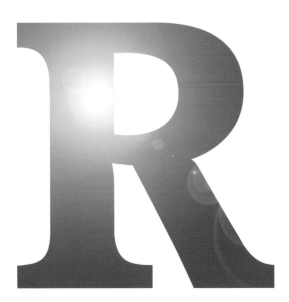

To see a few more examples of some PhotoShop and Eye Candy 4000 filters, we have started here with a simple blue circle. Remember that the circle is the most common foundation for a logo. There are many good reasons why circles work well. Just realize that as a graphic starting point, a circle has a lot of visual appeal.

In order to show how some filters affect the basic graphic, we have modified the circle logo by simply splitting it, making it unbalanced for visual interest.

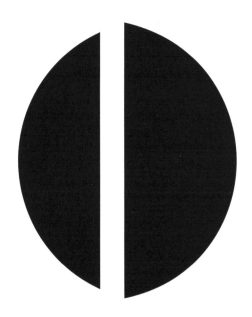

The split circle design
is then modified by
using Blur: Gaussian
Blur filter in
PhotoShop.

"Blur" can be many
different looks with
controls inside
PhotoShop. Here, the
blur is a Radial Blur.
One of the best
features of PhotoShop
filters is the multiple
controls that give you
enormous creative
freedom.

PhotoShop filters are extremely versatile. Here, we have the result of the "Distort: Twirl" filter.

Note: There is only a single control in this filter, but here you can see that a wide range of results of the "Distort: Twirl" filter is possible.

Here's how to make it…

The Distort: Ripple filter gives results like this. Again, you have a great deal of control of the finished piece, by using slider controls.

The "Distort: Wave" filter is shown with two different variations. The difference is in the strength of the wave, something that can be controlled by the user.

Note: When creating logos using PhotoShop or Eye Candy 4000 filters, keep experimenting within the slider controls to see the variety of effects that are possible.

> **Here's how to make it...** *Eye Candy 4000 has a "fire" filter that gives striking effects.*
>
> *This filter, like many in PhotoShop or Eye Candy 4000, has multiple slider controls to let you get the variations you want.*

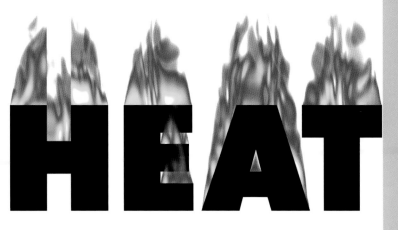

"Fire" for example, has these controls:

- Column Length
- Flame width
- Slide taper
- Movement
- Denser Flames
- Start from far side
- Sear only outside selection
- Random seed
- Direction
- Color

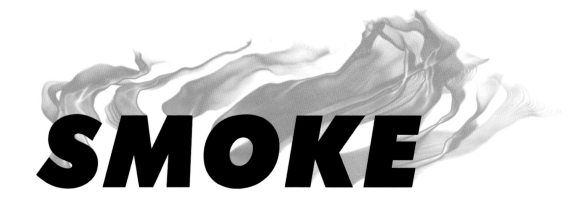

SMOKE

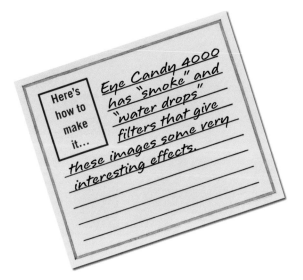

Here's
how to
make
it…

*Eye Candy 4000
has "smoke" and
"water drops"
filters that give
these images some very
interesting effects.*

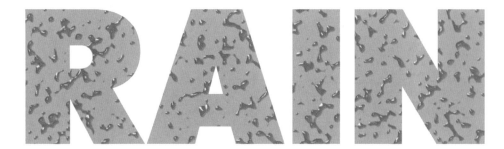

RAIN

WINDY CITY

The wind effect
comes from
PhotoShop filter
"Stylize: Wind"

BROWN DOG

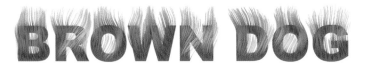

The Quick Brown Dog
solution is found in
the Eye Candy 4000
"fur" filter. This effect
has many slider
controls, including:
- Density
- Curl Size
- Curliness
- Length
- Colors

"**Typographic Logos,**"
he said.

Here's
how to
make
it...

*Type is an ex-
tremely effective
design tool to use
as the foundation
for many logos. The de-
signs in this section will
give you hundreds of
ideas for your own logos.*

FUTUR△
FOUND△TION

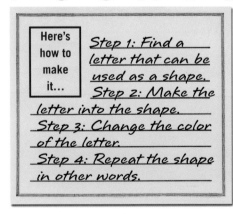

Here's
how to
make
it...

*Step 1: Find a
letter that can be
used as a shape.
Step 2: Make the
letter into the shape.
Step 3: Change the color
of the letter.
Step 4: Repeat the shape
in other words.*

Laffalot's

Here's how to make it...

To get a care-free, funfilled look, choose a whimsical type-face. then choose different colors on each letter.

Here's how to make it...

Here, instead of having a "type only" logo, we have used an oval background. (Try other shapes as well.) The type-face says "fun." The blue circles give added flash.

Rub • A • Dub

OKLAHOMA BO**OK**S

Here's how to make it... _Some names of businesses have letter combina- tions that can be highlighted. In this ex- ample, we made OK in bold type. The font used is American Typewriter, perfect for a bookstore._

Here's how to make it... _Specialty type- faces can create a highly memor- able look. In this design, the color has been made at the same angle as the typeface. Find the "just right" font for your next project._

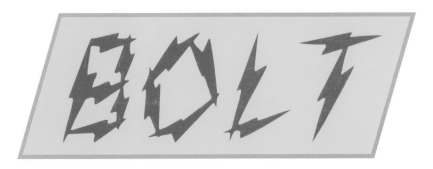

International fonts
can create a very
distinctive logo. This
Chinese font was to
make a neat logo with
just three characters.

Note: For authenticity,
the Chinese letters
read top to bottom.

Another note: Be
careful you don't write
something that is
obscene or offensive
in the language you
choose for a font.

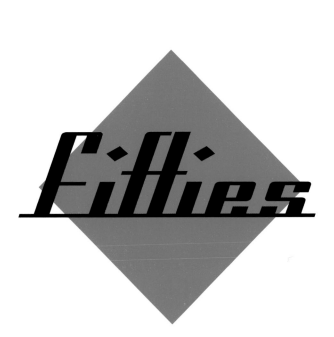

1. Another specialty
font gives a retro look.
2. The diamond shape
gives a different
background.
3. The color is even
retro, evoking images
of a 1955
Thunderbird.

The letter R works well when it's set backward. When the firm's initials are R&R, there are many visual possibilities. What other characters can be used in place of the "&"?

The lower case letters "b" and "d" are mirror images in many fonts. The "dave & bob" logo shows how well these letters can work as a single unit. What other letters work together in a similar way? Don't forget to think about caps as well as lower case letters.

dave & bob

The letter "B" works well in reverse image. The simple use of a reverse (white) circle makes this design stand out.

Take a good look at the name of the client. Letters of the alphabet have some interesting design possibilities, especially with certain combinations.

Design Hint:

AV WM
bd pq
fj mn VW

WM

Here's how to make it... The client name has M and W. To get an interesting look, we used an upside down W to make an M. Think of other possibilities for using this technique.

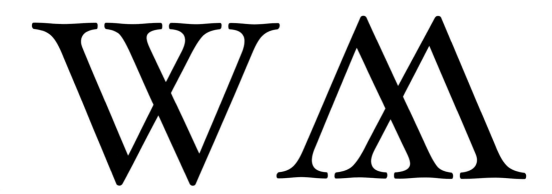

One possibility is to
overlap the two letters
as shown here.

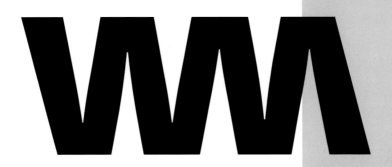

Try putting a rectangle
in the back. Or, use
the rectangle as the
logo, with the letters
in reverse.

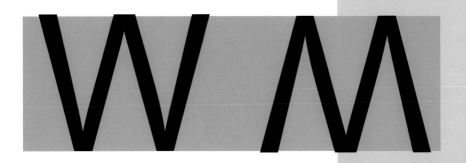

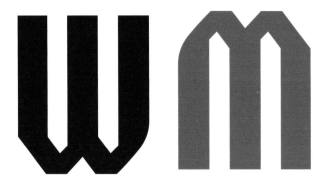

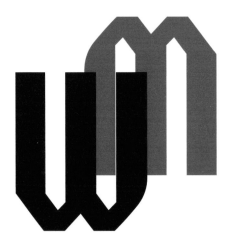

Here's
how to
make
it...

What other ideas might work? Try using con- trasting colors for the letters. Let your mind go free and see how many variations you can think of using the MW.

VASECTOMY

Here's
how to
make
it...

*Something as
simple as a white
line through black
type can make a
visual statement.
The letter O is also a
circle. Changing the O
into a round object can
make a memorable logo.*

M●RNING
SUNSHINE

Another specialty type face used nicely. It's always a good use of time to look through a comprehensive font book in search of a font that "speaks" the image of the business.

NOTE: The David E. Carter book, *The Big Book of 5,000 Fonts (and where to get them)* has a large number of specialty fonts shown. Check it out. It may be a valuable addition to your design library.

Blah, blah, blah.
Yadda yadda.

G^2

The assignment here was a logo for Gina Garza, a book publicist.First thought: GG initials have possibility.

Second thought: Using math notation G2 might be interesting.

Third thought: As a publicist, Gina "talks up" books. The thought balloon with Blah, blah, blah, seemed like a natural.

Fourth thought: "Yadda yadda" is a small tribute to Seinfeld.

Result is a very distinctive logo.

Note: As the first step in logo design, always look at the name of the client, seeking things that might be graphically interesting. The GG initials were a nice starting point.

Here's
how to
make
it…

Look at every client name for typographic possibilities. The name Perez has "ez" (easy) as a component. By simply using the letters EZ as an added dimensional effect, this logo was created.

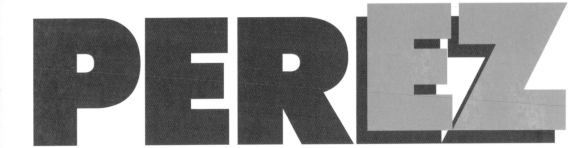

Turning a negative
into a positive:
Sabrina Ravipinto has
a last name that most
people read, then fail
to pronounce properly.
Solution: Use dictio-
nary-like dots to
separate the syllables,
and then use a red
graphic as accent
marks to show where
the emphasis on each
word should be.

Sa•bri•na

Ra•vi•pin•to

Memorable graphic,
and now everyone can
pronounce Ravipinto
properly.

Typographic Logos

A good beginning for any logo project is to set the name of the client in type, both upper and lower case. When we set the name Lila Harber in lower case type, the letters "lil" formed a reverse image of an H. This optical illusion provided the foundation for an unusual, memorable design.

lilalil

lila Harber

Note: Type logos can be extremely creative. Look for type solutions first. Even if you use a more graphic logo, the font may add distinctiveness to the final design.

Consider the Amper-
sand (&).

When this character is
part of the client
name, you may find
an interesting graphic
solution is nearby.
The & character has
many variations and
depending upon the
font being used, it
can create a wide
range of moods &
images.

> **Here's how to make it...**
>
> The corporate name in type, combined with an underline graphic, can make a strong logo. Note: When you are concerned with the possibility of creating a logo like someone elses, this technique is very good. The graphic is considered to be a "secondary device" and gives added protection from...

> **Here's how to make it...**
>
> ... infringement issues.
>
> For more logos like this, see the David E. Carter book, BulletProof Logos.

TravMatix

Here's
how to
make
it…

Step 1: Pick a type face that
works to create the right image
for the client. Step 2: Create
an underline graphic.
Step 3: Put these images on a red
background. Step 4: Change the bevel
look in Eye Candy 4000, inside
PhotoShop. (see the PhotoShop Filters
section for more on this.)

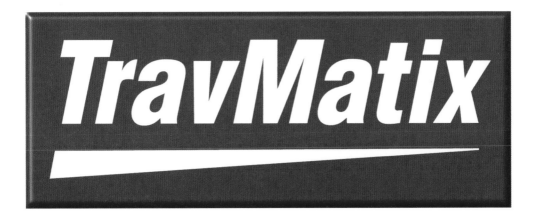

Here's how to make it...

Typographic Logos

Something as simple as changing colors and changing the angle of one type element can create an interesting logo.

Step 1: Choose an appropriate font and set the name in type.

Step 2: Change the type to red.

MOSA

MOSA

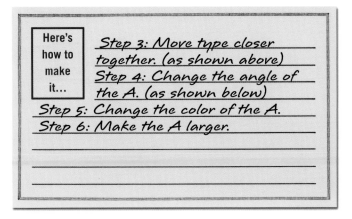

Here's how to make it... Step 3: Move type closer together. (as shown above)
Step 4: Change the angle of the A. (as shown below)
Step 5: Change the color of the A.
Step 6: Make the A larger.

MOSA

Kelton

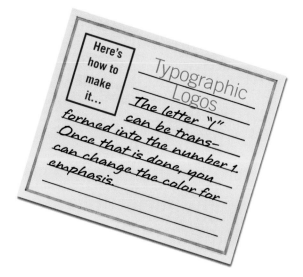

Here's how to make it…

Typographic Logos

The letter "l" can be trans-
formed into the number 1.
Once that is done, you
can change the color for
emphasis.

Ke1ton

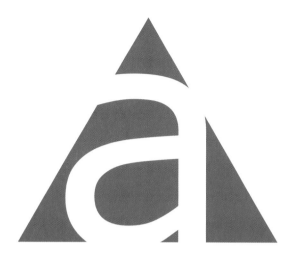

Here's
how to
make
it…

*Use a single
letter for the logo.
Add a background
shape, then make
the letter exceed the
boundaries of the shape.
Below is one with similar
style, add the company
name for variety.*

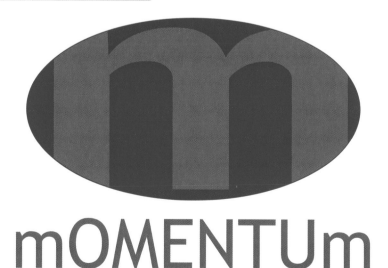

mOMENTUm

COLLINS • CENTER

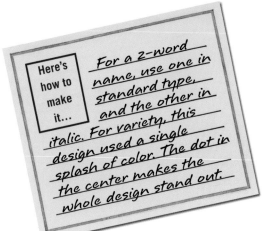

Here's how to make it... For a 2-word name, use one in standard type, and the other in italic. For variety, this design used a single splash of color. The dot in the center makes the whole design stand out.

Here's how to make it... Typographic Logos For the logo at the bottom of the page, we have used a staggered effect to achieve a look that is appropriate with the client's name.

HILLSIDE

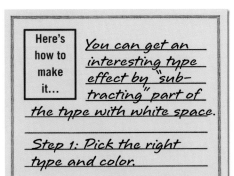

Here's how to make it... You can get an interesting type effect by "subtracting" part of the type with white space.

Step 1: Pick the right type and color.

SNOW DAY

SNOW DAY

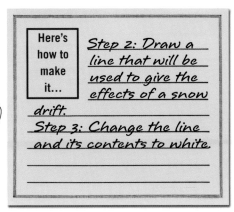

Here's how to make it... Step 2: Draw a line that will be used to give the effects of a snow drift.
Step 3: Change the line and its contents to white.

SNOW DAY

EIEIO

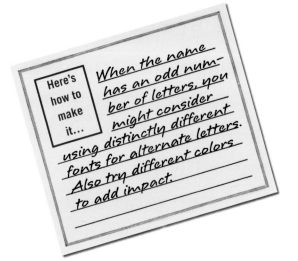

Here's how to make it...

When the name has an odd number of letters, you might consider using distinctly different fonts for alternate letters. Also try different colors to add impact.

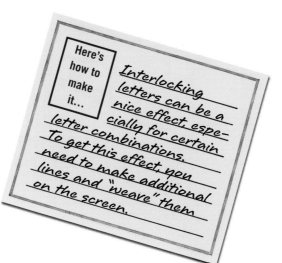

Here's how to make it...

Interlocking letters can be a nice effect, especially for certain letter combinations. To get this effect, you need to make additional lines and "weave" them on the screen.

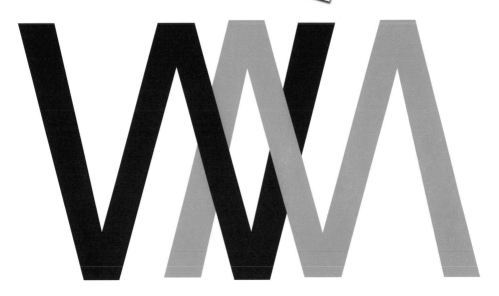

Modifying letters is easy in drawing programs such as FreeHand, Illustrator and others. This offers many design possibilities.

UNDERLine

By using the "convert to paths" function under type, you can turn type into art, and then make any changes you wish. The small change to the X here gives a distinctive touch to the logo.

Navix

Navix

Let's stay with the Navix design for a few more modifications, just to see some other ideas.

Here is another modification that adds a touch of class to the design. The simple change of dotting the "I" with blue gives it an added dimension.

Navix
The Navix 9

A couple of changes here. First, we have moved the letters closer together. Next, the addition of a brand—The Navix 9—within the logo.See how the blue box under the Navix name "fits" into the x in Navix. And note that the ix is the Roman numeral for 9.

Thin type, thick type vary the thickness of fonts drastically, and you get a nice appearance.

INTERSTATE **DATA**

Color helps a lot.

INTERSTATE **DATA**

A second color makes it much better.

INTERSTATE **DATA**

And changing one font to italic makes it even more interesting.

INTERSTATE **DATA**

Finally, adding an underline finishes the design.

INTERSTATE **DATA**

TV3

Modifying letters, and then connecting them can make interesting logos. Watch this one as it is created. The type starts off like this.

TV3

Now, the T and 3 are modified and brought into the V.

TV3

Color is added to get the effect of separating the TV and the 3.

Now, let's look at how this could be taken into a background shape.

Here you see how the shape fits the logo.

Now we'll put a color into the oval background. A whole new image springs forward with the addition of yellow.

Next, we'll take this design into PhotoShop.

Here's how to make it...	Typographic Logos
	Once in Photo-Shop, we use the "Bevel Boss" filter of Eye Candy 4000 two different times to get this look.

Note that the letter G has an arrow hidden within some fonts... When your client's name begins with G, remember this...

Use different weights of type to create interesting, appropriate graphics.

Here, we've made the "fat" a little fatter by changing the type to paths, then adding points and rounding the type into a more plump look.

G

Go

LOSE FAT

LOSE FAT

This design features starkly contrasting fonts, both in weight and in size. And the position of the two type blocks gives it additional visual interest.

computer
TECHNOLOGY

Sanibel

September

Contrasting type faces, set inside a box, creates visual interest. The use of "handwriting" fonts can make design stand out.

Here's
how to
make
it...

Typographic
Logos

The letter M has been modified by using "additive" changes, with extensions to the letter. This simple change creates an interesting effect.

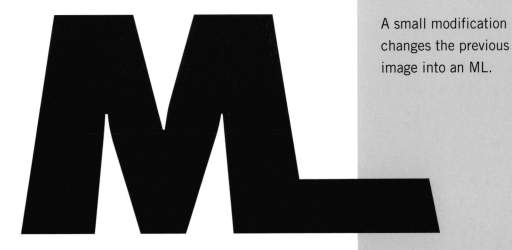

A small modification changes the previous image into an ML.

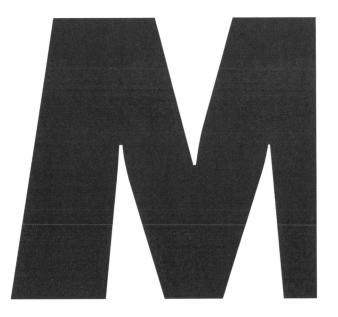

Here we have blocked part of the letter M to give it an interesting effect.

Try this with a variety of letters. Subtract different areas of the letters and see what interesting effects you can get.

Repeating Shapes can be a nice graphics technique for creating exciting logos.

This simple yet effective logo was done with basic step and repeat command within FreeHand.
The use of primary colors adds to the appropriatness of the design.
CMYK are standard ink designations: Cyan, Magenta, Yellow and Black.

There are many ways
to use multiple
squares to create a
logo. Here, we have
used the contrast of
multiple square and
one circular element
for a logo.

OSWALD

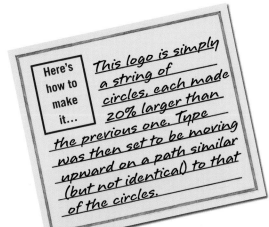

Here's
how to
make
it...

This logo is simply
a string of
circles, each made
20% larger than
the previous one. Type
was then set to be moving
upward on a path similar
(but not identical) to that
of the circles.

TRAJECTORY

This repeat shape
simply took the dot
over the "i" in tennis,
and then used the
interesting "T" in the
font to serve as a
tennis racket. The
multiple tennis ball
effect adds a lot to
this logo. Look for
typographic images
that can enhance your
design in this way.

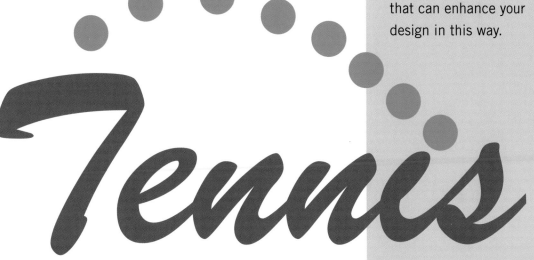

Repeating shapes can mean repeating the entire name in type. By using progressively lighter ink tints, the word "Merge" is shown visually merging.

Merge

The same technique can be used on an object. Here, though, the underlying object is not a tint of the original top color, but is a slight gray.

Keep your mind open to variations from logo recipes that you see in this book.

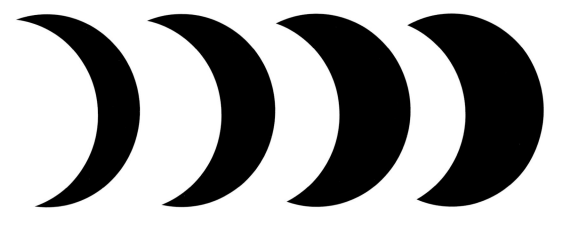

Here's how to make it...	Repeating Shapes
	Repeating a shape can take on variations. Here, we have used the phases of the moon to create an interesting design. When you think, think outside the box. Look for common objects for inspiration for using repeat shapes while creating logos.

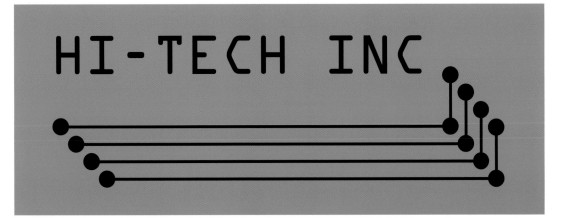

Here's how to make it...

Repeating Shapes

Simple shapes can be used in a repeat pattern and the result can be striking.

(See the Design Elements section of this book for more details on creating design elements such as this.)

INDIANA

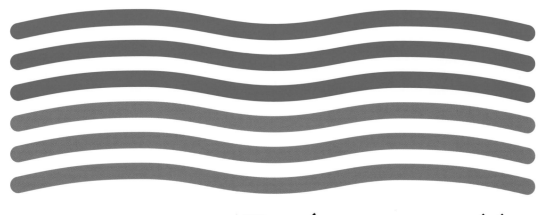

Riverside Hills

Here's
how to
make
it...

Using a repeat
shape and then
changing color
can often be a
good design technique.
Look at shapes and say
"what if?"

Here's how to make it...

Many logo elements are created by using repeat elements.

Whenever you begin a logo project, ask yourself "is repeat shapes possible here?"

Here's how to make it...

Repeating Shapes

The repeat pattern may have many forms. Here, the concept of family dentistry is shown by multiple tooth brushes in various sizes.

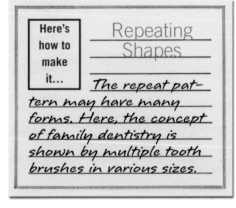

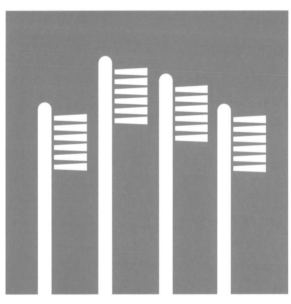

Family Dentistry

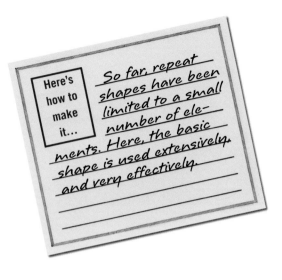

Here's
how to
make
it…

_So far, repeat
shapes have been
limited to a small
number of ele—
ments. Here, the basic
shape is used extensively,
and very effectively._

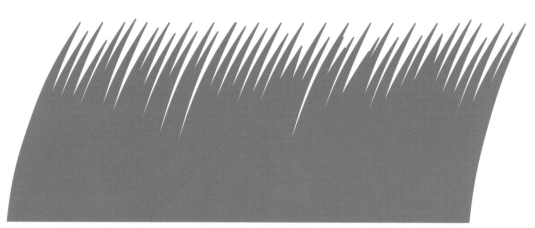

LAWN SERVICES

Here's
how to
make
it...

The shape shown below is another example of taking a simple shape and using it repetitively. The pinwheel graphic below is a good start for the beginnings of an eye-catching logo.

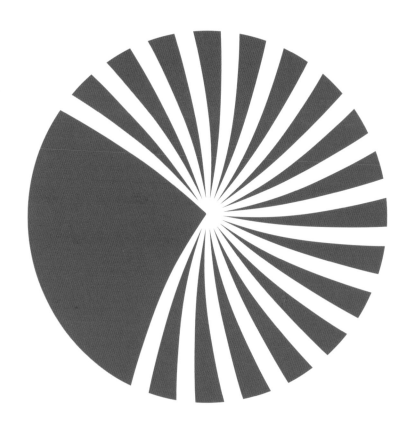

Here's
how to
make
it...

Repeating Shapes

The oval can be made into many exciting design elements. Step 1: Simply duplicate the oval and move across the layout. Step 2: Create a green rectangular box. Step 3: Place ovals across green box and change color of ovals to white. Step 4: Add type on top.

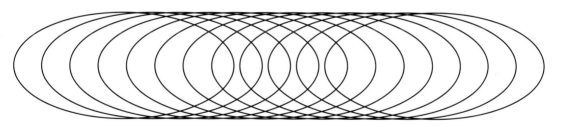

PERMANENT RECORDS CORPORATION

Getting the letters to appear as though they're "interlocked" (image shown at the top left) is as simple as placing a "patch" on the top letter. On the following pages we'll see how it's done.

Step 1: Lay one letter on top of the other. Change the colors as desired.

Step 2: Put a "patch"
on the area that
intersects.

Step 3: Change the
patch color to match
the "top" letter color.

Here's
how to
make
it...

When the client
name consists of
double initials
there are many
possibilities for using re-
peat shapes.
Here are two good ex-
amples on these two
pages.

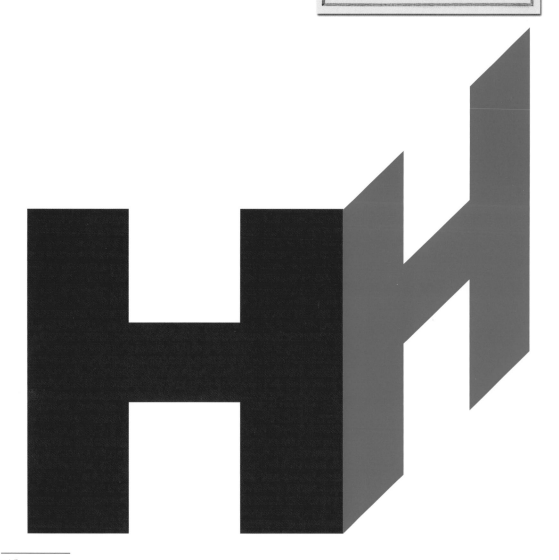

Simple repeat pat-
terns can be effec-
tively used under the
business name to
create eyecatching
logos. You can almost
see the books on a
shelf from the logo
shown here.

AMANDA BOOKS

▮▮▮▮▮▮▮▮▮▮▮▮▮▮▮▮▮▮▮▮▮▮▮▮▮▮▮▮▮▮▮▮▮▮▮▮▮▮▮

Repeat shapes have many possible forms. Here, the shape at left was the starting point. Note that this element is not particularly well drawn, is not a "smooth" work of art.

Here, we have used the basic shape, and modified each one so they are slightly different. Still, the look of the piece is a little ragged, and does not really have a finished look.

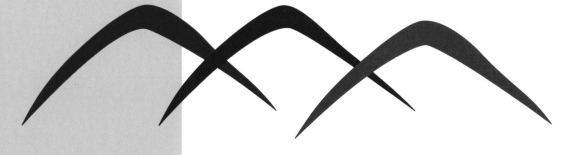

<table>
<tr><td>

**Here's
how to
make
it...**

</td><td>

Repeating Shapes

*Here, though, we have a very
nice logo design. This image
was taken into PhotoShop
and the "Distort Ripple" filter was
used. Always be aware of the power
Photo Shop and Eye Candy 4000
filters have to creat unusual looks from
otherwise bland graphics.*

</td></tr>
</table>

You will find objects for repeat shapes use in many places. The musical note here is something that is used as a repeat shape in a "natural" habitat.

strings

Repeat shapes are
everywhere. This
"honeycomb" look is
a great beginning

The basic shape has
been modified, and
the type inside has
also been partially
skewed to match the
shape.

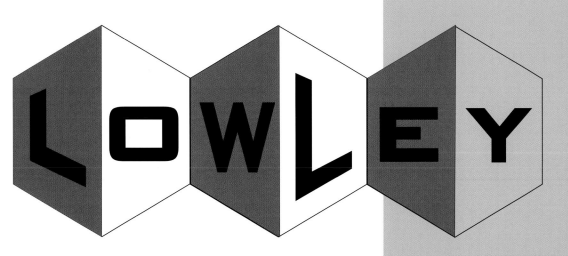

By using variations of
the basic shape
above, this interesting
logo emerges.

A simple straight line takes on an interesting character when it is repeated along an arc.

We will create an interesting logo by adding a rectangle to the image above.

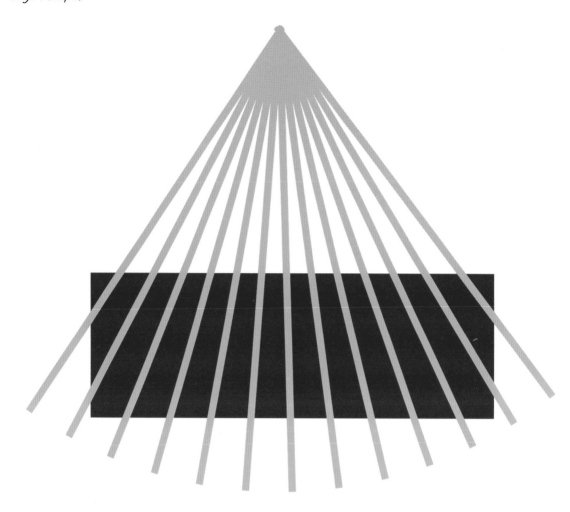

Here's how to make it...

Repeating Shapes

The repeat lines are then placed over the rectangle. This is an intermediate step along the way to an interesting logo.

Here's how to make it... *The repeat lines have been "pasted inside" the rectangle, creating a plowed field image. By adding the type below, we have created an interesting effective logo.*

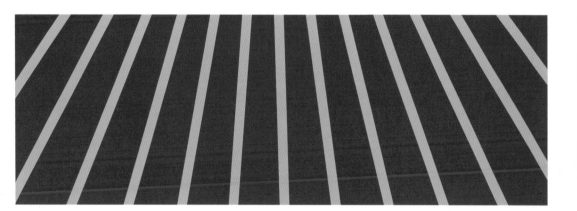

AGRICULTURE

Repeating Shapes

Here's how to make it…

Repeat shapes are everywhere. By using different fonts and different colors for the question mark symbol, we have created a compelling design. What other type characters lend themselves to this technique?

???????

ANSWERS!!

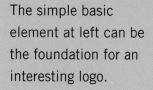

The simple basic
element at left can be
the foundation for an
interesting logo.

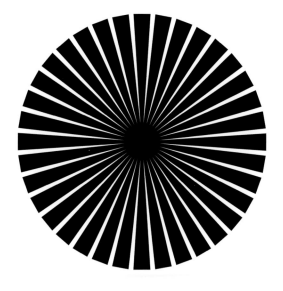

Here, we simply
copied and pasted the
image to create this
graphic circle.

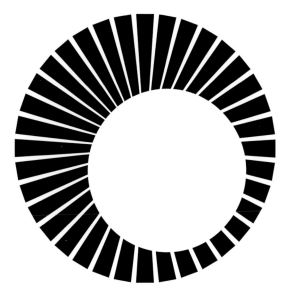

Next, we place a
white circle on top of
the element. Position-
ing the circle off-
centered creates
visual interest.

Here's
how to
make
it…

This is a good start for an interesting logo. Let's change the white circle to a color and see what happens. Remember, don't be afraid to experiment with changing shapes and colors.

Here's
how to
make
it…

We now have a different look, and by placing the graphic in a box we can see an interesting visual taking place. Watch as it all comes together on the next page.

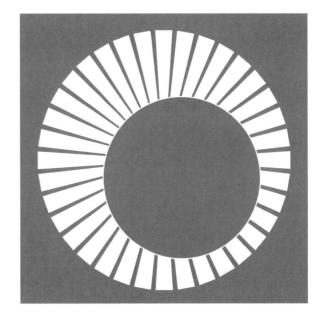

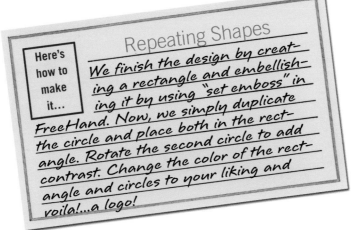

Repeating Shapes

Here's how to make it...

We finish the design by creating a rectangle and embellishing it by using "set emboss" in FreeHand. Now, we simply duplicate the circle and place both in the rectangle. Rotate the second circle to add contrast. Change the color of the rectangle and circles to your liking and voila!...a logo!

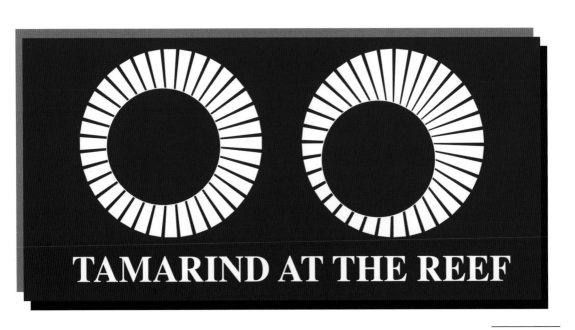

TAMARIND AT THE REEF

Here's how to make it… *The basic circle can be used with repetition to create many interesting graphics. By taking this image into Photo-Shop and using "mosaic filter", the results are striking..........*

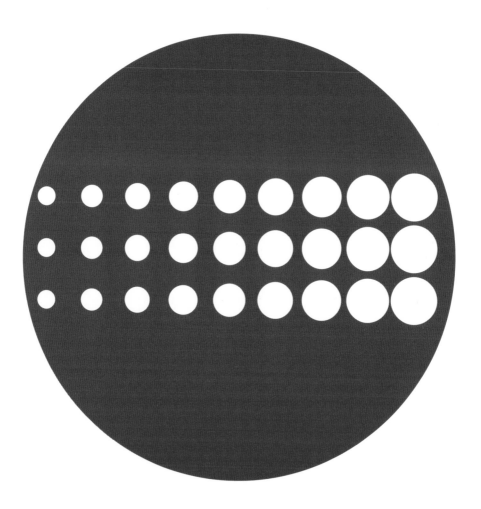

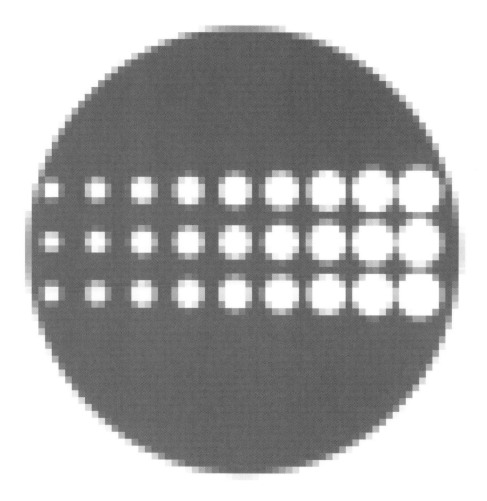

Here's how to make it...

Here, we've taken a straight element, bent it, and then made copies of it in a circle. We then put two different colors behind the image, in order to highlight the dimensional effect of the graphic

Circles.

Different sized circles.

Different sized circles placed into a diamond shape.

This design has a lot of possibilities, such as coloring each circle with a different color, or a different tint of the same color or...

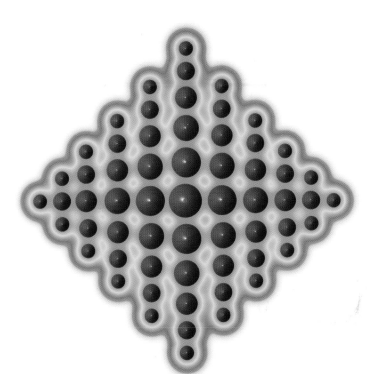

...taking the image into PhotoShop and using the "Bevel Boss" and "Gradient Glow" filters in Eye Candy 4000. The "before and after" logos show the power of filters.

Repeating elements can also be created by using the "Blend" tool feature in FreeHand. We start with the two images shown here.

Continuing with the two elements from above, the "Blend" tool essentially creates a progressive set of changes in between the two starting elements to create this effect.

By creating two elements of varying size and having them face different angles, the end result is a dimensional look that's quite interesting.

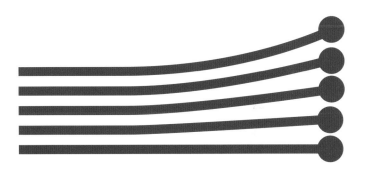

DRUM FESTIVAL

The slight shape changes in the drumstick were accomplished once again by using the "Blend" tool in FreeHand. Adding a rectangle and type gives us this graphic.

The hint of a dimensional circle becomes an even stronger graphic when it is repeated and extended. When thinking about repeats, think dimension, and think different thicknesses of those dimensions. The curved line of type was done by using the "Attach to Path" tool in FreeHand.

THE ORIGINAL FISHING WORM FARM

This dimensional feeling of flight was done with the "Blend" tool in FreeHand. The multi-color underline was done with the "Gradient" tool also in FreeHand.

Here's
how to
make
it...

Try "cutting" your design element to make an even more interesting design. Even consider changing colors for the two element pieces. Enclosing it in a circle gives us a finished look.

Here's how to make it...

We then take the design from the previous page into PhotoShop, where the "crystallize" filter was applied, and then the "shadowlab" feature in Eye Candy 4000 finished the design.

Here's how to make it...

Repeating Shapes

This is another example of using the "blend" tool in FreeHand to create repeat shapes. The interesting shape is enhanced by placing it in a circle.

Here's how to make it...

We then take the shape into PhotoShop. First, the Bevel filter was used, then the Swirl filter, adding the right amount of enhancements to our interesting shape.

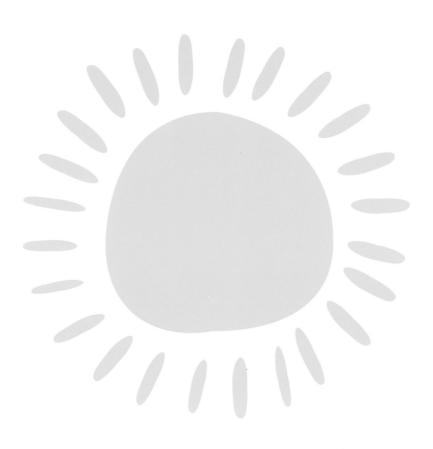

Here's how to make it...

Repeat shapes don't have to be used symmetrically. Our free-form "sun" uses a repeat shape, but the position and shape of each ray is different. Always look for multiple solutions.

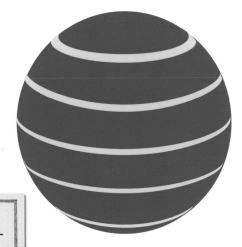

Here's how to make it...	Repeating Shapes

Similar shapes made from an original curved line gives us a "planet" shape. We then place the graphic on top of a blue circle, and change the graphic to yellow. After using the "pointillize" filter in PhotoShop we end up with a nice planetary image.

> **Here's how to make it...**
>
> *Repeat shapes don't have to be large. Here, we are using small squares in different colors to get the "confetti" look. Note the "white space" to enhance to overall look.*

Hidden Treasures

> **Here's how to make it...**
>
> *For a starting point, let's look at a very simple repeat shape. This one is simply triangles pointing to the business name. (Simple CAN be effective, as shown here.) What other shapes might be used here? How about having the repeat shapes on a different angle? What images can you think of?*

Here's how to make it... The "toothpick" shape is a nice design element. Here, we have used it as a blade of grass to create a logo for a lawn service. What other places would be appropriate for the business name? What if you cut off a few of the "blades" as though the grass had been cut? What other images do you see?

Howard's Lawn Service

THE TRADING CO.

Red Ball Inn

Here's how to make it...

Repeating Shapes

The Red Ball Inn logo is very simple. Yet, it's very effective. The repeat of the balls emphasizes the name of the business. Remember: simple CAN work very well for a logo. What if the red balls were dimensional rather than flat?

Square Shapes can be the foundation for a huge variety of logos.

Here, we begin with simply placing type in the middle of a square.

Now some variety begins. We have made the logo 2 colors, and have added a line of type at the bottom.

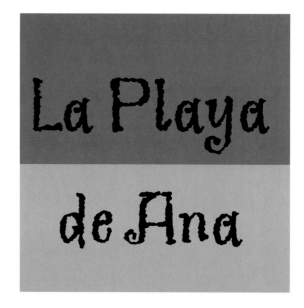

> **Here's how to make it…**
>
> _The square is the foundation here, but the way the type overlaps gives the edge of the square a distinctive look. This could be the name of a PBS program, or the Spanish translation "won't go."_

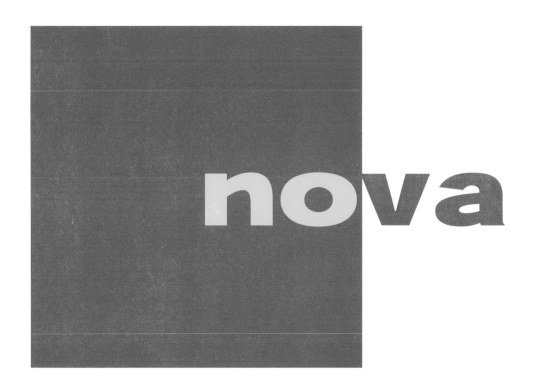

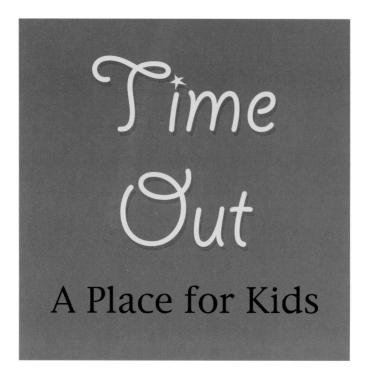

Time Out

A Place for Kids

Here's how to make it...	*Try using two extremes of font style. Here, we have changed the color of one font making it stand out on the purple background of the square, resulting in a very striking look.*

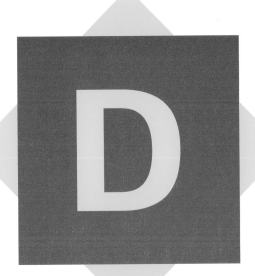

Two squares, the yellow one is simply rotated 45 degrees.

By placing the yellow D on the red square, it makes the square appear to be die-cut.

By adding a drop shadow, the appear-ance of a die-cut letter is enhanced. Adding the drop shadow to the yellow gives it a further dimensional look.

Note: the drop shadow is not black, but 80% tint of black. Solid black makes the edge too harsh.

Here is another
version of the logos on
the previous page.
When you think in
terms of squares,
remember that
squares turned 45
degrees become a
diamond shapes.

Here's how to make it...

The "flip" logo uses a child-like printing font. Always keep interesting font styles at the ready for any logo you create.

Now, watch as we take the logo below and.....

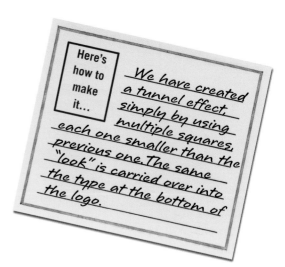

Here's how to make it...

We have created a tunnel effect, simply by using multiple squares, each one smaller than the previous one. The same "look" is carried over into the type at the bottom of the logo.

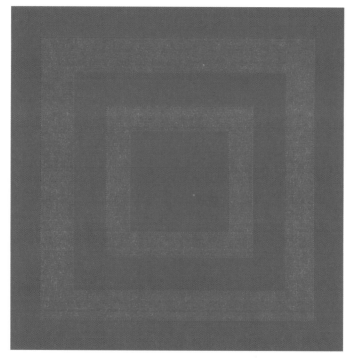

PERSPECTIVES

WOODVALL

Here's how to make it... _When you have a strong initial letter for the client name, use the letter so large that it nearly covers the square background. What other letters could be used to get this effect?_

FULL COUNT, A BAR

Here's how to make it... *Don't forget to experiment with placement. By slightly rotating the squares we have a logo with extra interest. Think of all the variations squares can provide. Think checkerboard.*

Here's
how to
make
it…

*Try using mult-
iple blocks and
multiple colors.
Try changing the
angle of two blocks
equally. Then make two
more and change the
color. How many other
configurations are there?*

BEFORE

Here's how to make it... | Square Shapes

Amazing scientific fact: a square turned on its side and stretched becomes a diamond, as shown here.

AFTER

Here's how to make it...

Here we have taken multiple diamond shapes and placed them in a staggered pattern giving us an effect of stacked items. How can you use this for your current client?

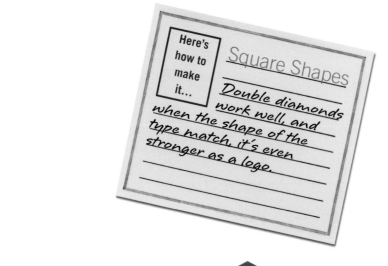

Here's
how to
make
it...

Square Shapes

Double diamonds
work well, and
when the shape of the
type match, it's even
stronger as a logo.

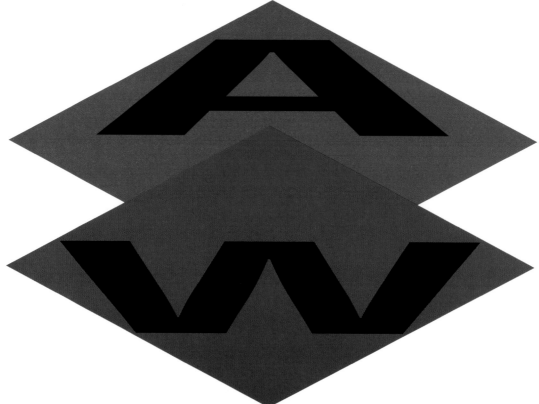

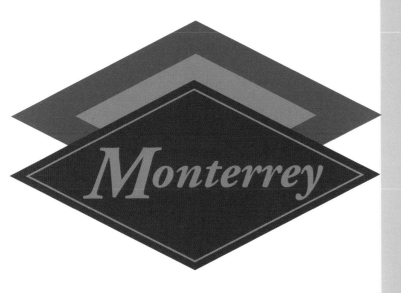

By placing the smaller pink diamond inside the larger one, and placing the blue diamond in front, we have a "quiltlike" effect. Adding text helps to complete the look, but not quite...

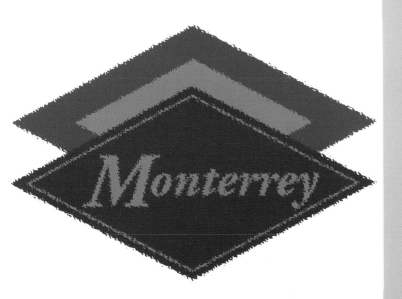

...by taking the design into PhotoShop and using the "Ripple" filter we have taken a "bland" logo and given it a new dimension. Experiment with different filters to obtain the look you want.

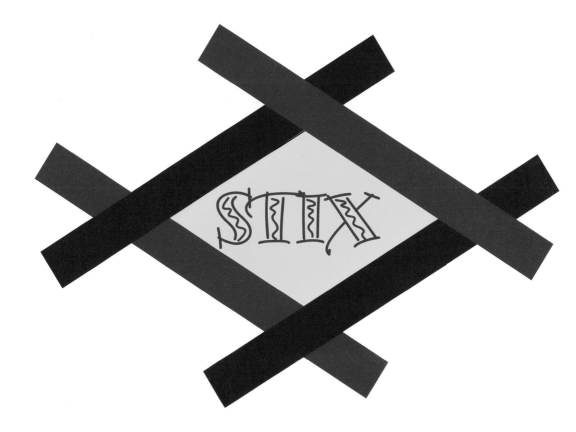

Here's how to make it...

Diamond shapes can be made of many elements. Here, the red and blue rectangles form the diamond. The yellow is just fill, and finally the font is appropriate for the image we've created.

Here's how to make it...	The STIX logo was taken into PhotoShop and the Corona filter was used to create this compelling logo. Note that the color of the corona matches the tint inside of the diamond.

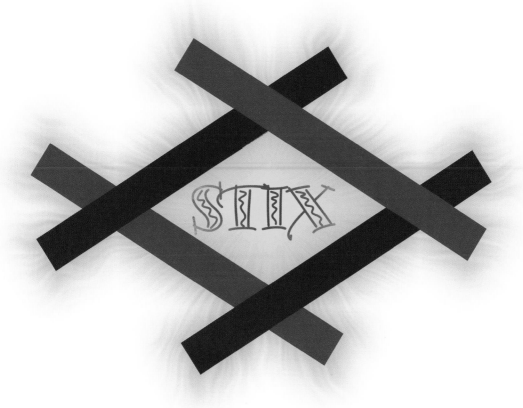

Painter 8.0 is a great specialized graphics program that offers a huge variety of styles of output, including:

Acrylics

Airbrushes

Blenders

Calligraphy

Chalk

Coners

Colored Pencils

Crayons

Digital Water Color

Distortion

Erasers

Fx

Felt Pens

Goauche

Impasto

Liquid Ink

Oil Pastels

Oils

Palette Knives

Pastels

Pattern Pens

Pencils

Photo

Sponges

Tinting

Water Color

Friday's Donuts

Here's how to make it...	Painter Effects
	Painter effects can be used in many ways, including creating unique "secondary devices" that can underline the company name set in type. The pages in this section show a small sampling of the varieties of graphics you can get from this program

Blue Streak Creations

Here's how to make it...

Painter Effects

Blue Streak Creations:
Airbrush – Coarse Spray

Purple Haze Records:
Airbrush – Soft Airbrush 50

Purple Haze Records

Buck's Paintball Supplies

Here's how to make it...	Painter Effects
	Buck's Paintball Supplies: Airbrush – Variable Splatter
	Fakir's Oriental Rugs: Ancient Sandstorm Pen

Fakir's Oriental Rugs

Uncle Sam's Paint

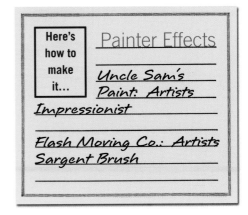

Here's how to make it...	Painter Effects
	Uncle Sam's Paint: Artists Impressionist
	Flash Moving Co.: Artists Sargent Brush

Flash Moving Co.

Cotton Candy

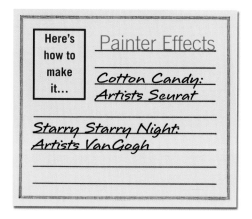

Here's how to make it...

Painter Effects

Cotton Candy:
Artists Seurat

Starry Starry Night:
Artists VanGogh

Starry Starry Night

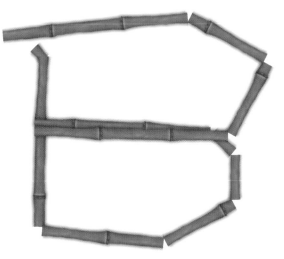

Bangkok Buck

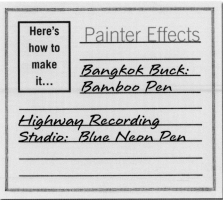

Eden's Gardens

Here's how to make it...	Painter Effects
	Eden's Gardens: Curling Tendril Pen
	Panda Restaurant: Eucalyptis Shoot Pen

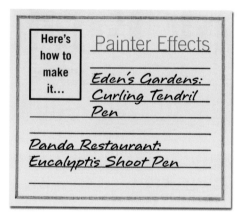

PANDA RESTAURANT

Dusty's

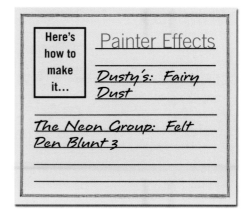

Here's how to make it...	Painter Effects
	Dusty's: Fairy Dust
	The Neon Group: Felt Pen Blunt 3

The Neon Group

Bachman, Turner, Bachman & Company

Here's how to make it...	Painter Effects
	Bachman, Turner, Bachman: Felt Pen Design M10
	Dead of Night Publishing: Flying Blackbird Pen

Dead of Night Publishing

Fuzzy Blue Caterpillar Lounge

Mrs. Ruth's

C.K. DEXTER HAVEN GENTLEMEN'S CLUB

Here's how to make it...

Painter Effects

C.K. Dexter Haven: Golden Neon Pen

Major Tom's Ground Control: Ground Cover Hose

Major Tom's Ground Control

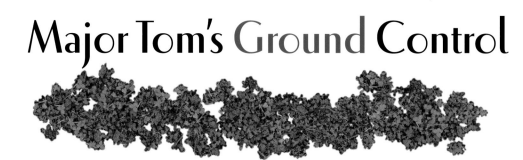

Barry's Berries

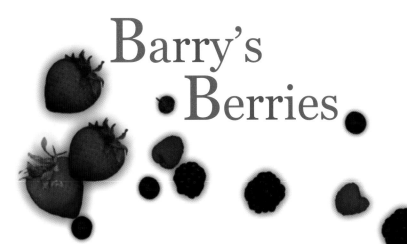

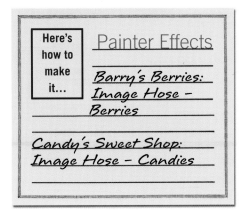

Here's how to make it...	Painter Effects
	Barry's Berries: Image Hose – Berries
	Candy's Sweet Shop: Image Hose – Candies

Candy's Sweet Shop

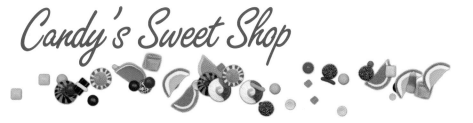

Party Supplies

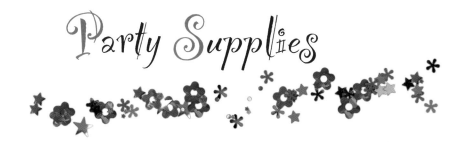

Here's
how to
make
it...

Painter Effects

Party Supplies:
Image Hose:
Confetti

Marbles Game Room:
Image Hose – Marbles

Marbles Game Room

Dad's Junk

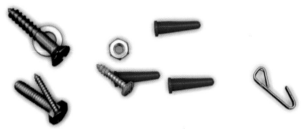

Painter Effects

Here's how to make it...

Dad's Junk:
Image Hose –
Nuts & Bolts

Under the Sofa: Image
Hose – Party Mix

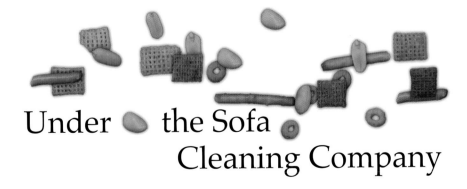

Under ● the Sofa
Cleaning Company

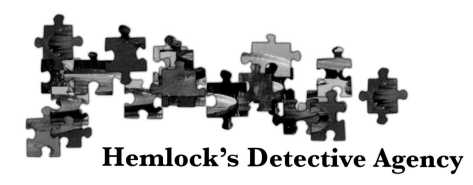

Hemlock's Detective Agency

Here's how to make it…	Painter Effects

Hemlock's Detective Agency: Image Hose – Puzzle

She Sells Seashells: Image Hose – Seashells

She Sells Seashells Jewelry

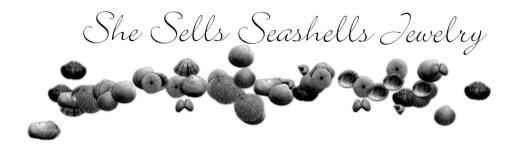

Blue Caulk Sealants

Here's how to make it...

Painter Effects

Blue Caulk Sealants:
Impasto – Gloopy

Martha Riding Stables:
India Textile Pen

Martha Riding Stables

Bungle Jungle Tours

Here's how to make it...	Painter Effects
	Bungle Jungle Tours: Jungle Weed Pen
	Rakes Lawn Service: Leaf Hose

Rakes Lawn Service

Cadence's Dance Studio

Here's how to make it...

Painter Effects

Cadence's Dance Studio: Loaded Pallet Knife

Overdrive Construction: Stucco Hose

OVERDRIVE CONSTRUCTION

W. C.'s Magic & Sleight of Hand

Here's how to make it...	Painter Effects
	W.C.'s Magic: Playing Card Hose
	Sarah's Roses: Rose Bouquet Pen

Sarah's Roses

Gearhead Masonry

Here's how to make it...	Painter Effects
	Gearhead Masonry: Stone Wall Hose
	scribbles designs: Pallet Knife

scribbles designs

Here's
how to
make
it...

Painter Effects

The Pompeii
Club: Wave
Mosaic
Pearl's Boutique:
Succulent Pearls Pen
Agapé Threads:
Twisted Yarn Pen

The Pompeii Club

Pearl's Boutique

Agapé Threads

Will's Place

Soft Focus Photography

Mary's Florals

Here's how to make it...	Painter Effects
	Will's Place:
	Wide Stroke 50
Soft Focus Photography:	
Neon Pen	
Mary's Florals:	
Grainy Wet Sponge	

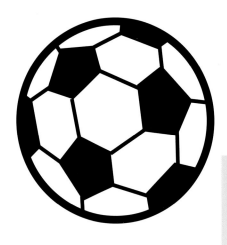

Here's
how to
make
it...

Logo Extras

*This section of the book in-
cludes thoughts I have had
over the years; many don't fit
into any of the other categor-
ies. Nonetheless, they are all things
worth having as part of your store-
house of logo design knowledge.
We start with the volleyball graphic to
the left, let's see what happens.*

Here's
how to
make
it...

*Wishing to get a
"motion" effect,
the colors were
first changed.
Then, the graphic was
taken into PhotoShop,
where the Corona effect
was applied from Eye
Candy 4000.*

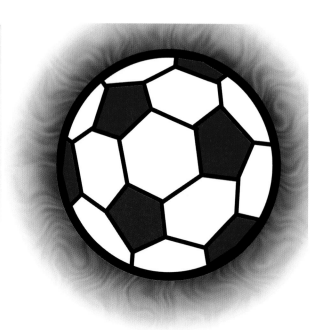

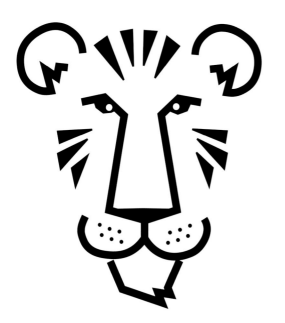

Here's how to make it...

When you have created a detailed graphic, consider using just a part of it for the logo. By using just a part of the Tiger's face we have created an interesting logo below.

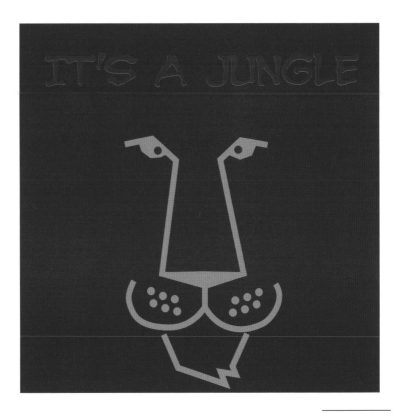

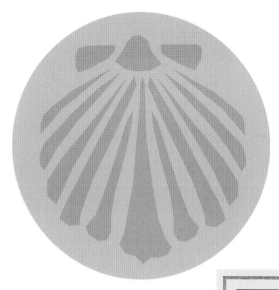

Here's how to make it...	The shell design above is a good use of closely contrasting colors. This is a nice design as it is. But my theory is: Try different stuff. Try other looks, just to see "what if?" So...we took the design into PhotoShop and added "Noise" then gave it added dimension in Eye Candy 4000's "Bevel Boss."

| Here's how to make it… | _Still in Photo-Shop, we used the "Crystallize" filter, with nice results._ |

These options are done quickly with PhotoShop and Eye Candy 4000 filters. Remember: Try different stuff.

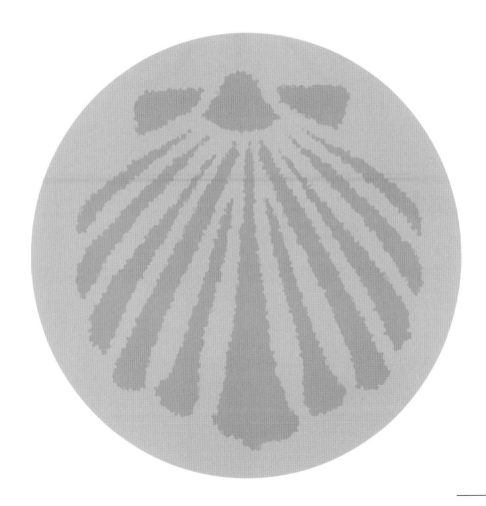

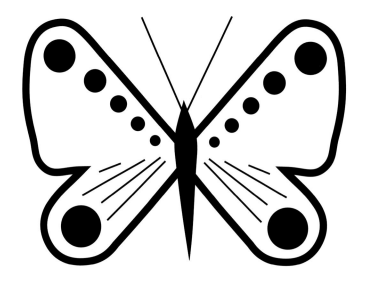

Here's
how to
make
it...

When you have
elements that
work well in color,
go with the many
possibilities. Here, we
start with a simple image
of a black and white but-
terfly. Let's see where we
end up on the next page.

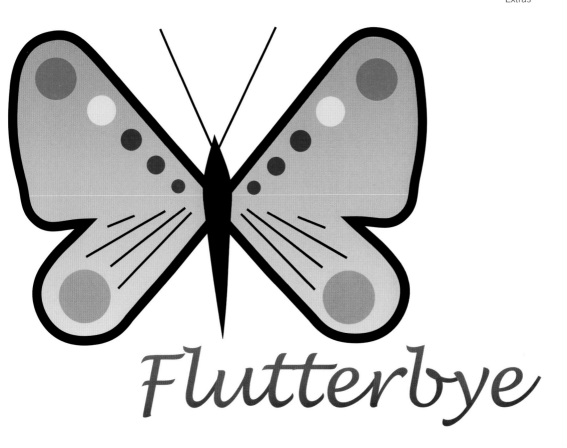

Flutterbye

Here's how to make it...

We took our image into Free-Hand and used the "Gradient" fill on the wings. This lets you choose the two blend colors and the angle of the blend. The wings were then filled with symmetrical colors: pink blending to yellow. We use this same effect on the type: red blending to green, to add pizzaz.

Here's how to make it...

Go for the visual and verbal surprise. Set up the audience with 1–2, and then give them a surprise with 3. The use of animal tracks gives us another distinction. Go for the unexpected!

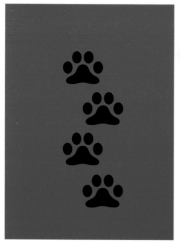

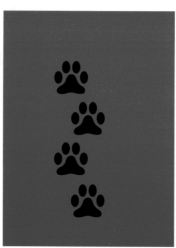

LIONS & TIGERS & DUCKS
OH MY!!

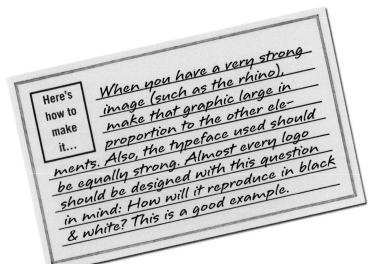

Here's how to make it...

When you have a very strong image (such as the rhino), make that graphic large in proportion to the other elements. Also, the typeface used should be equally strong. Almost every logo should be designed with this question in mind: How will it reproduce in black & white? This is a good example.

Big-O Rhino

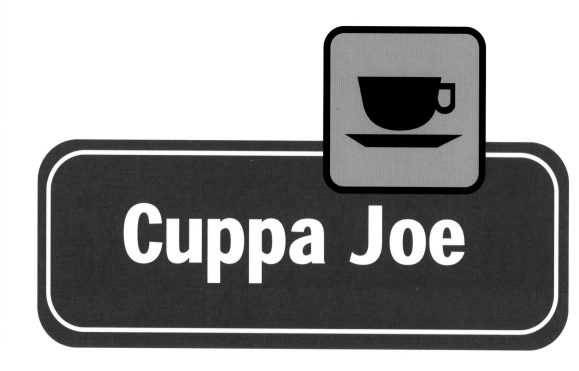

Cuppa Joe

Here's how to make it...

Logo Extras

For many clients, the presence of a travel-based business is a good chance to use a design with a highway sign motif. As shown in the logo above.

Here's how to make it...

Look for inspiration from far-away places. Here, we have used some pre-Columbian symbols to create interesting logos. Whenever you are "inspired" save it in your "logo catalogue."

Here's how to make it...	Logo Extras

Whenever you can, take interesting designs into PhotoShop and see just what might come from the filters. Let's start with our base image, the fish shown above. The first step was to add some color to the fish. We added two different shades of blue to give us definition.

> **Here's how to make it...**
>
> _Here, we have taken the blue fish from the previous page into PhotoShop where we've used the "Pixellate: Pointellize" filter. We have an interesting visual as shown below._

Here's how to make it...

Logo Extras

Here is a nice technique: duplicate the letter M, change the color to gray, then skew the gray letter so that it has a shadow effect. As shown in the graphic above.

Here's how to make it...

Another variation of the logo from the previous page is to use a different letter for the background letter as shown here. How many other variations can you think of?

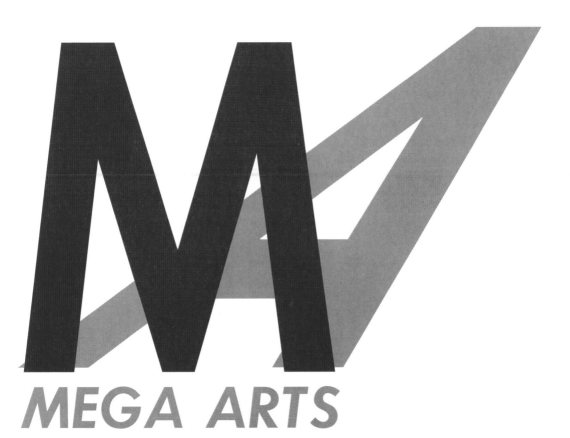

MEGA ARTS

Here's how to make it...

Logo Extras

A solid object such as the turtle can be made into a nice beveled object by using the "Bevel Boss" filter in Eye Candy 4000, a PhotoShop plug in. Below, we started with the bevel look, then added the yellow "Gradient Glow" filter from Eye Candy 4000. A striking appearance.

Here's how to make it...

Logo Extras

Don't confine your creating to just shapes. Here, we've taken a simple font and a single letter, and by using the "Shadowlab" effect, (Eye Candy 4000), we have created a nice design. Note that the opening inside the A allows the background shadow to be seen. Other letters with this characteristic are...?

Here's how to make it...	Logo Extras
	When creating a two-dimensional black & white element, think how you can add visual interest to it. For this simple oak leaf, we added blended colors (red to orange) in FreeHand. Already our image has taken on a completely different look.

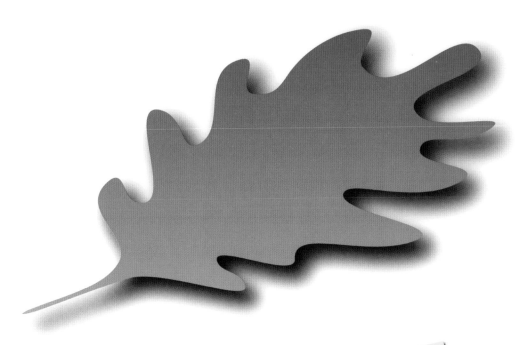

Here's how to make it...

We take our image into Eye Candy 4000 in PhotoShop and use "Shadowlab" to get this nice effect.

Here's
how to
make
it…

*Break the rules
on color.
Yes, red and pink
can work together
for a logo. And yes, blue
and green are good com-
binations. Don't let color
preconceptions keep you
from being creative.*

| Here's how to make it… | *First, this caution: Crosswords can be tricky. Elementary school children discover this technique early on. But when done with style, this can work well. The design below works because of the black rectangles that simulate the crossword puzzle look and the font that resembles handwriting.* |

TAMARIND

Here's
how to
make
it...

*Use extended or
compressed type
for visual impact,
as well as for
spacing.
This is the normal font,
Futura Condensed Demi.
Here is the same type
below, but stretched.*

TAMARIND

LOGO SUPERPOWER

LOGO SUPERPOWER

Here's how to make it... Long words may have a better visual appearance if the spacing between letters is compressed. Using the font OCRA Alternative, we see normal spacing then compressed spacing.

GOTTAGORIGHTNOW

> **Here's how to make it...**
>
> _Don't put spaces between words. Instead, use different colors._
>
> _Reduce the amount of space consumed by multiple lines of type by overlapping the lines._

White Picket Fence

When the client is appropriate for this technique, use a design style that might be called "childlike" or "primitive."

Here's how to make it...

This simple little box can be the foundation for a neat logo. You have options on where to put the type, what colors to use, and you always have the options inside PhotoShop.

Here's how to make it...

You get some very interesting effects by using the "Transparant" feature of programs such as FreeHand, Illustrator, PhotoShop and others. The only limitation you have here is your mind.

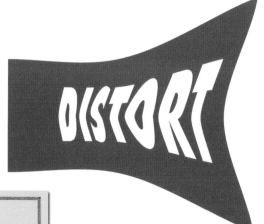

DISTORT

DISTORT

DISTORT

Here's how to make it...

Logo Extras

There are many programs that let you distort graphic images by creating an "envelope" of any shape you like, and then converting the original graphic to fit inside the envelope. Here are a few examples of what you can do. The options are limitless.

FreeHand and other programs have pre-defined patterns that you can use to fill elements with.

You can fill everything from shapes to letters with this tool.

The crossbar of the A
has many different
possibilities for
change.

Two are shown here.
What others can you
think of?

FreeHand and other drawing programs let you set type, and then create a "path" that the type will be joined with.

The arc shown below the type is the path we will follow.

AROUND THE WORLD

Here is the finished product.

AROUND THE WORLD

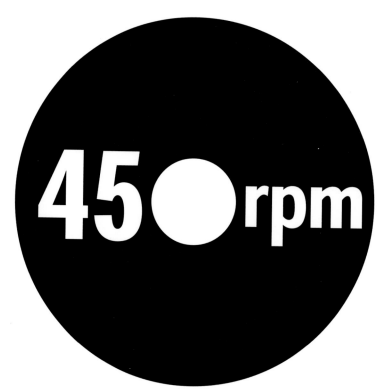

45●rpm

A 50s Restaurant

Here's how to make it...	Logo Extras
	Look everywhere for inspiration for designs. Here, the 45 rpm record of the fifties is the inspiration for both the name and the logo of this restaurant. And the typeface below the main logo is reminiscent of the chrome styling on the side of a fifties automobile.

BUMP
IN THE ROAD

| Here's how to make it... | _Don't be afraid to let your mind wander to visual representations that virtually "speak" the words._ |

Open your mind to the use of letters that don't stay in line.

This simple oval in black doesn't look like a very exciting graphic.

But when you add "blended" colors to the design, and then make three different colored versions of it, it becomes very exciting.

| Here's how to make it... | *Here, the single blended color image of our oval was taken into* PhotoShop *and the* "Glow Rainbow" *effect in Eye Candy 4000 was used.* |

| Here's how to make it... | *Here is another variation. The single blended color image was taken into* PhotoShop *and the* "Glow Pride" *effect in Eye Candy 4000 was used.* |

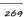

THOMPSON

> **Here's how to make it…**
>
> *This is a nice technique for producing logos. This is simply a repetition of squares, with a different colored set being used to create the letter T.*

> **Here's how to make it…**
>
> Logo Extras
>
> *You can create a ransom note look by using different fonts and then creating a "cut out" look.*

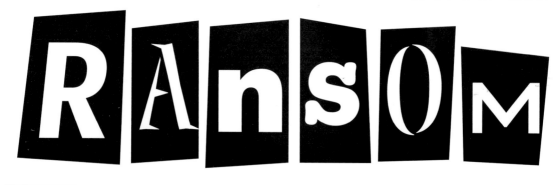

David E. Carter

Here's how to make it...	*You can get some interesting logo variations from stock illustrations that include let-ters. This typewriter keyboard*

effect was used for a sample logo for the author of this book. The name at the bottom was set in a typewriter font and then put into "Bevel Boss" of Eye Candy 4000 and then Shadowlab.

About the Author

David E. Carter is the bestselling author/editor in the history of graphic design books.

In 1972, when there were *no* logo design books available, Carter produced *The Book of American Trade Marks, Volume 1*. (Seventeen publishers rejected that book before it was published; it went on to become one of the bestselling graphic books ever.) To date, he has written or edited nearly 90 books on the topic of corporate identity.

By 1978, Carter had produced 10 books related to corporate image; that year, he conducted seminars for *Advertising Age* in New York, Chicago, and Los Angeles. His corporate identity seminars eventually expanded around the world to locations such as São Paulo, Brazil, Helsinki, Finland, and Singapore.

In 1989, Carter established a major presence in Asia as a design consultant. Through affiliate offices in Bangkok and Jakarta, he managed identity projects for a large number of multinational firms in the Pacific Rim.

While corporate identity is Carter's specialty, he has had a variety of other business interests. In 1977, he founded an advertising agency that soon qualified for AAAA membership. He wrote and produced an ad that won a Clio Award in 1980. In 1982, he started a TV production company and won seven Emmy Awards for creating innovative programs that appeared on PBS. He also produced a large number of comedy segments which appeared on *The Tonight Show Starring Johnny Carson*.

His first book for general audiences, *Dog Owner's Manual*, is a humorous book and was published in the spring of 2001 by Andrews McMeel.

Currently, he is working on several new corporate identity books, as well as editing the annuals, *American Corporate Identity* and *Creativity*.

Carter worked his way through school, earning an undergraduate degree in advertising from the University of Kentucky, and holds a master's degree from the Ohio University School of Journalism. More recently, Carter returned to the classroom to earn an MBA from Syracuse University in 1995. He graduated from the three-year Owner/President Management program (OPM) at the Harvard Business School in 1998.